Focus on Flight

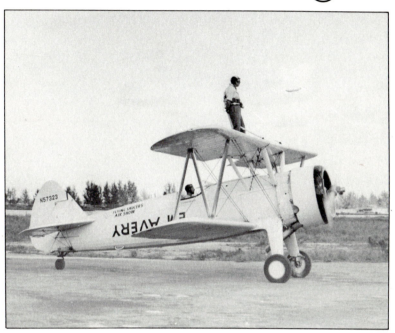

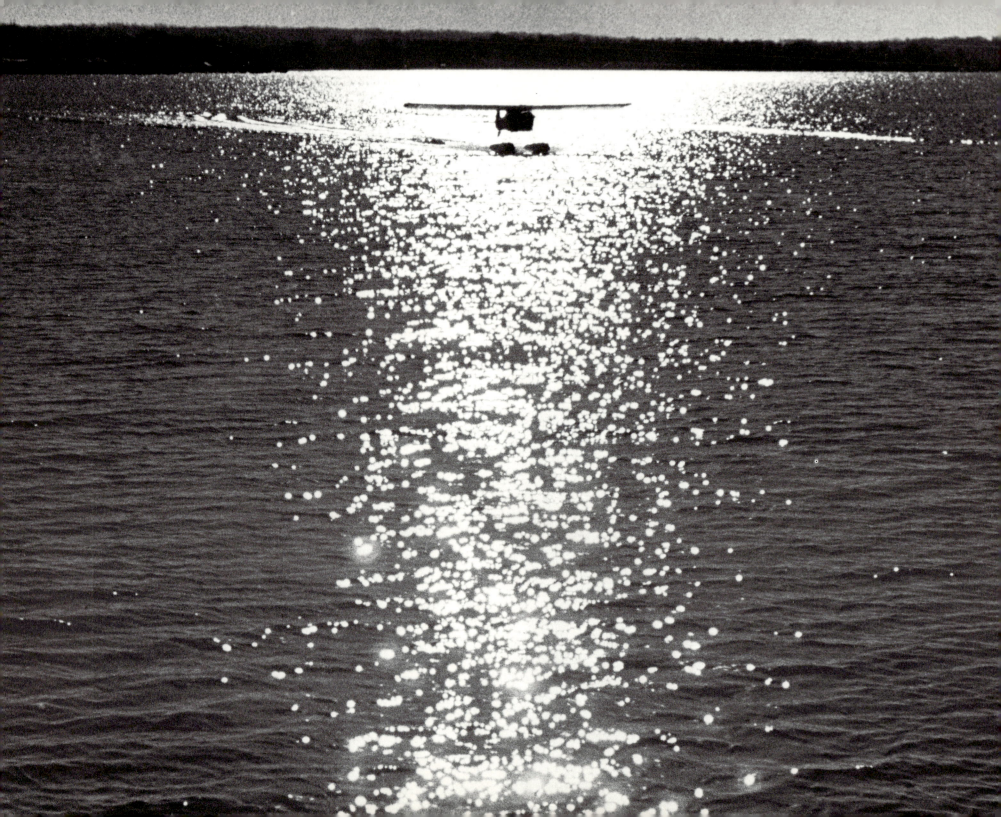

Focus on Flight

E. T. Wooldridge

The Aviation Photography of Hans Groenhoff

Published *for the* NATIONAL AIR AND SPACE MUSEUM *by the* SMITHSONIAN INSTITUTION PRESS • Washington, D.C. 1985

Cover. Bell XP-39B Airacobra, 1941.

Half-title page. Hans Groenhoff, wing walker.

Frontispiece. Taylorcraft BL-65, Miami, 1937.

Title Page. Grumman G.22 *Gulfhawk II,* c. 1938.

Back cover. Hans Groenhoff.

AT RIGHT: Douglas B-18A, Mitchel Field,
 New York, c. 1937.

Library of Congress Cataloging in Publication Data

Wooldridge, E. T.
 Focus on flight
 1. Groenhoff, Hans. 2. Photography of airplanes.
 3. Photographers–United States–Biography. I. Title.
 II. Title: Aviation photography of Hans Groenhoff.
 TR140.G74W66 1985 770'.92'4 85-600167
 ISBN 0-87474-973-5

∞™ The paper used in this publication meets the
minimum requirements of the American National
Standard for Permanence of Paper for Printed
Library Materials Z39.48–1984.

Book design by Christopher Jones

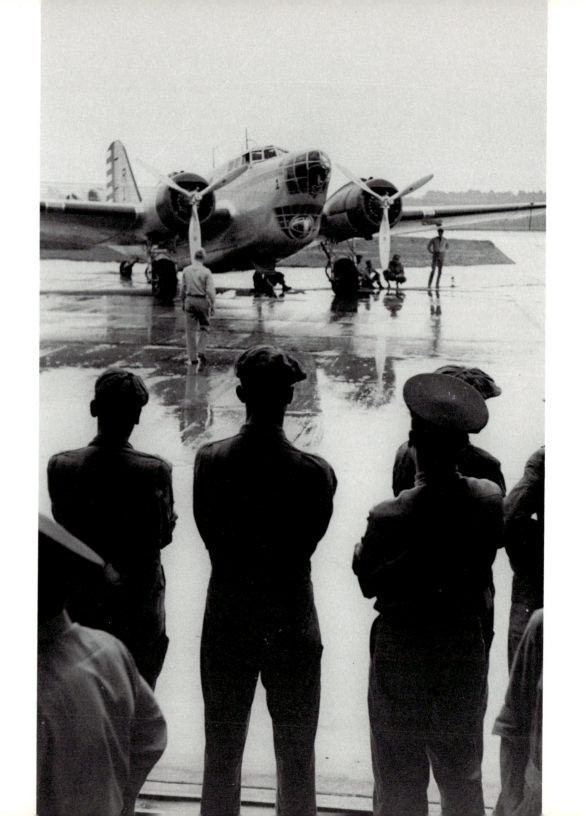

Contents

Foreword

Photography has endowed us with the means to record and behold visual impressions that pass before our eyes in a relentlessly changing pattern and hardly ever return. With all its refinements, the camera is a magical tool that freezes fleeting images and preserves them, to be seen and enjoyed over and over again.

With the camera, the photographer captures a scene, an event, an expression, people, and interesting objects—first at random and then with growing insight and choice—to record and remember. With experience, the photographer learns to judge the values of the interplay of light and color, perspective, depth, and composition. The photographer learns to observe, and by appraising the observations, learns to see more and better. The addition of the photographer's personal touches—in the composition of the photograph, in the selection of light and shadow, in the way shapes are fitted into a frame, in the very choice of mood—

Gulf Tour Lightplane Cavalcade,
West Palm Beach, Florida, 1936

results in what may well be called a work of art.

While I have tried my hand at fashion photography, architecture, sports, and travel, I have always been enthralled by, and turned back to, my first and true love—the sky. Flying and portraying flight and the sky have been a hobby of mine, a challenge and an obsession now for more than fifty years.

From gliders to Piper Cubs, Wacos, and Staggerwing biplanes, from DC-3s to DC-10s, from Learjets to Phantoms, I chased them all, sat in them, flew them, and posed them for my camera. In my eyes they were wings of wonder and their domain was the sky. On the ground I would aim up at them from a low angle, with nose and wing pointing skyward to project them against their element. Airplanes on takeoff, climbing steeply and reaching for height, make dramatic pictures, especially when backed by a spectacular sky. At airshows I, like thousands of fans, would be spellbound by the gyrations of aerobatic daredevils, roaring, rolling, looping, spinning, and painting garlands of whirling white smoke against a crisp blue

sky. When I caught a good one and looked at it afterwards, I could still hear the roar of the engines and the cheers of the excited crowds.

In flight I carefully planned every shot, showing an airplane at close range; formations of planes forming and dissolving, peeling off in steep turns; or a tiny speck of a plane against a mighty bank of clouds to demonstrate the beauty and the exuberance of flight. I was forever fascinated by the changing scenery of the skyscape, by plumes and puffs and mushrooming clouds. I pursued them as stage settings for my photos of airplanes, or merely to behold them on film. On cross-country flights I sometimes chased cloud formations until I wound up too high, way off course, with storms raging below and the fuel tanks nearly empty.

Motivated by my own joy of flight and love of the sky, I succeeded not only in finding fulfillment in my work with the camera, but also found satisfaction in my ability to convey my impressions and experiences to many who could not be along, but yet, like myself, would derive enjoyment from viewing and recognizing the pictures.

I usually knew when I had a good picture at the instant I clicked the shutter. I never tired of the joy of a first look at a good one, and the knowledge that it would also give pleasure to other viewers gave me much satisfaction.

As page after page of the first proof of this book unfolded to my view, a strong wave of thankfulness welled up in my heart, and I came to realize that it takes much more than personality and an absorbing subject matter to enliven the pages of a book. There are intangibles in time and place outside one's control. There are events of great impact, the inspiration of great deeds, the upsurge of progress, and happenings of lasting effect. But more than that, there were people with whom I walked side by side, or who just happened to cross my path and left their footprints behind. They were strangers and friends, companions and comrades in arms, reporters, writers, cameramen like myself who pedaled their bikes miles out to the nearest airstrip to watch the planes and perhaps trade some menial task for a little flying time. There were the barnstormers; the daredevil racers and aerobats; and the aces, the tall idols who had reached great heights in aeronautical skills and achievements.

As I turned the pages, I also recognized and appreciated how much diligence and dedication were spent to reflect the splendor and excitement of our flying age, of our conquest of the sky. I owe everlasting thanks to Walter J. Boyne, director and "wizard" of the National Air and Space Museum (NASM) and its Silver Hill Annex, for recognizing and caring for my photo collection. My deep appreciation goes to E. T. Wooldridge, chairman of NASM's aeronautics department, who mastered the difficult task of sorting out the material, to dramatize it in his inimitable style and to give the book wings. Above all, I owe loving thanks to my wife, Fran, who walked beside me and gave me strong support through all the up-and-down currents of the exciting years of our lives.

—*Hans Groenhoff*

Introduction

On May 21, 1927, Charles Lindbergh completed his remarkable solo flight across the Atlantic. He emerged from the *Spirit of St. Louis*, exhausted from over 33 hours in the cramped cockpit, to be met by thousands of screaming, jubilant people. They poured onto the runway at Le Bourget airport near Paris to welcome the courageous aviator they called the "Lone Eagle."

At the same time, 4,000 miles westward, another aviator approached his final destination, only a few short miles from the site of Lindbergh's takeoff just the day before. The aviator was a German immigrant, and he was one of many passengers aboard the Hamburg-American Line's SS *New York* just arriving from Hamburg, Germany. An enthusiastic crowd welcomed the *New York* as it docked at the Hudson River piers of New York City. Hans Hermann Hugo Ernst Wilhelm von Groenhoff clutched his *One Thousand Words of English*, waved back to the crowd uncertainly, and wondered at the imposing, majestic skyline of Manhattan.

Hans Groenhoff, the young man who would eventually become one of the world's outstanding aviation photographers, had arrived. He was fresh from his law studies at the University of Heidelberg, he had twenty-five dollars in his pocket, and proudly bore a prominent dueling scar on his forehead. He also possessed considerable pride, determination, and an innate, artistic talent that would surface in dramatic fashion within a few short years.

Groenhoff had left behind a family of lawyers and ministers and his younger brother Günther, a famous pilot in Germany, whose gliding and soaring records had made him a legend in his own right. Groenhoff also left a Germany in which "the political situation looked hopeless." Naziism was beginning to spread, and there were riots in the streets. He had already been arrested for fighting the Fascists in Italy, and his reputation as a political activist was growing. All things considered, Columbia University in New

York seemed an attractive option for his law studies, and with a promise to his father to return in five years "to talk things over," young Groenhoff left for a better world, carrying his little English book and the minimum twenty-five dollars required by law. It would be many years and times would be much better before he would return.

Groenhoff quickly settled in to the immediate task at hand—survival in a big city. He avoided the local German societies, trying to shake off the vestitures of his other life as quickly as possible. By day, he was dishwasher, busboy, waiter. At night, he retreated to the *New York Times*, where sheer determination, perseverance, and a thorough grounding in Latin and ancient Greek eventually led to his mastery of English. A 1934 article on gliding in *Esquire* was the first of many that appeared in later years under the Groenhoff byline. His interest in gliding, developed with his brother during earlier days in Germany, was renewed in the early thirties at Elmira, New York, a city which was to become the cradle of American gliding. As the sport attracted public interest, Groenhoff articles appeared in the Sunday newspaper supplements, and his professional writing career began to blossom.

During these early days in New York, a singular, tragic event occurred which changed the course of Groenhoff's life. In 1932, Günther, distinguished airman, test pilot, and active photographer, was killed during the annual gliding contests on the Wasserkuppe mountain in Germany. From Günther, Hans inherited two excellent cameras. It marked the beginning of a distinguished fifty-year career as aviation photographer, journalist, editor, correspondent, and publicist.

Acknowledgments

The author is grateful to Mr. Hans Groenhoff, who provided personal recollections of his unique career as one of the world's outstanding aviation photographers. Assisted by the welcome observations of his loyal and devoted wife, Fran, Hans shared his memories of a fascinating and rewarding life, from his boyhood on the slopes of the Wasserkuppe in Germany through the idyllic, later years in the Bahamas.

To Walter J. Boyne, director, and Donald S. Lopez, deputy director, National Air and Space Museum (NASM), go my thanks for providing guidance and support during the preparation of the book. Trish Graboske, Bob van der Linden, Helen McMahon, and Jay Spenser of NASM provided welcome advice and assistance. Special thanks go to Claudia Oakes for conducting an excellent interview of Hans Groenhoff, Ron Davies for contributing his editing expertise, and Kathleen Brooks-Pazmany, keeper of NASM's Groenhoff Collection, for assistance in selecting and processing the photographs. Bob Storck, a friend of NASM, provided invaluable information on the aircraft and personalities of the early days of gliding at Elmira.

To Sybil Descheemaeker goes my sincere appreciation for her usual superb job of typing and correcting the manuscript.

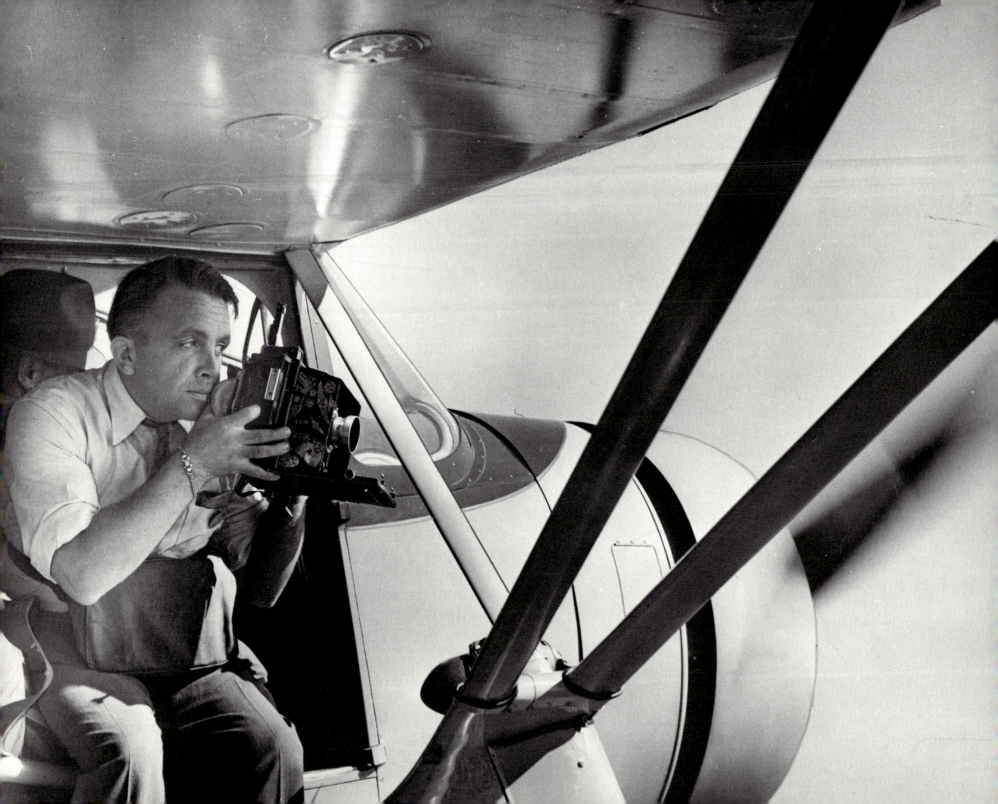

Hans Groenhoff
Aviation Photographer

Groenhoff pursued his love of aviation in the New York area, where he began to experiment with the two cameras he had inherited from Günther. Initially Elmira, with its growing glider activity, and then nearby Roosevelt Field, proved to be ideal locations to record the aviation events and personalities of the age. Not until he had perfected and honed his photographic skills in other fields, however, did Groenhoff's name begin to appear with some regularity in the aviation periodicals of the day. At first, his photographs could be found in large, glossy fashion magazines. As Groenhoff recalls, his work even appeared in *Spur*, one of those "horsey society magazines." On rare occasions, a plumbing and heating journal would call on Groenhoff for a contribution.

By 1937, the frequent trips to Elmira and Roosevelt Field had begun to pay dividends. More and more "photos by Groenhoff" appeared in aviation periodicals, and he was finally offered the job of staff

Groenhoff demonstrates his photographic techniques in a Fairchild F-24, c. 1939

photographer for Frank Tichenor Publications, publishers of *Aero Digest* and *Sportsman Pilot*. He spent all of his waking hours at the airports around New York, ranging from Roosevelt Field to the seaplane base at Port Washington, Long Island, meeting many of the leading personalities in aviation, business, and society. Aviation country clubs began to spring up around New York and neighboring states, as sport aviation became more popular. The rich and the famous congregated to show off their recent purchases and discuss the latest happenings in sport and business aviation. Professional and social relationships with Howard Hughes, Bill Lear, "the Russians" Seversky and Sikorsky, William Piper, Charles Lindbergh, "Wrong Way" Corrigan, and others were all in a day's work for the indefatigable Groenhoff.

As he continued to refine his photographic skills and techniques, Groenhoff's reputation as a consummate professional grew and spread to every segment of the aviation community. The Groenhoff mystique had grown to the point where he could afford to free-

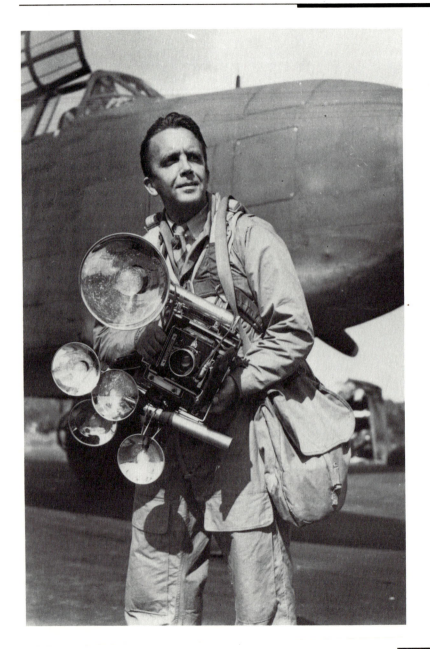

Groenhoff used five synchronized flash bulbs while photographing 1941 army maneuvers at night.

lance. Airlines, industry, publishers, promoters—all demanded the special brand of Groenhoff photography. His pictures appeared in *Collier's*, *Time*, *Life*, *Popular Aviation*, *Fortune*, *Popular Science*, *National Geographic*, and dozens of other magazines, newspapers, and supplements. He also did advertising and publicity photography for aircraft manufacturers such as Piper, Beech, Aeronca, Cessna, Grumman, and many others.

As World War II approached, Groenhoff continued to be deeply involved with general aviation activities, flying Piper J-3 Cubs and Aeronca Champs with a group called "The Grasshopper Pilots." With William Piper and other professional and amateur enthusiasts in the aviation community, Groenhoff demonstrated the capabilities of these light planes to the U. S. Army. They even participated as civilian pilots in the 1941 Louisiana maneuvers. It was a perfect opportunity for Groenhoff to record photographically the state of U. S. military preparedness on the eve of America's entry into World War II.

During the war, Groenhoff was in demand by all of the leading aviation journals and the armed forces, as well as by airplane builders who were eager to present their latest fighter or bomber for the special Groenhoff treatment. Some of the more frightening episodes of Groenhoff's action-packed career took place during the war years, when the eager photographer, always seeking a challenge, frequently risked his life to satisfy his own high standards.

Groenhoff emerged from the war with his reputation

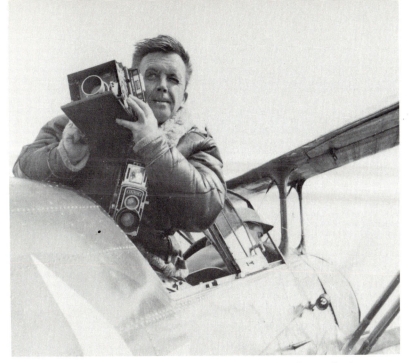

The observer seat of this Douglas O-46A provided an ideal vantage point from which to photograph military aircraft formations.

considerably enhanced. His exciting, imaginative color photographs of military aircraft were seen daily by millions of Americans, whose awareness and appreciation of military aviation had been heightened by daily media accounts of aerial combat, personalities, and the latest improvements in aviation technology. He returned to his prewar pattern of activities, working with the airlines, and doing some free-lancing, until 1954, when he moved to Florida. He was attracted in part by the opportunity to photograph aircraft in a totally different environment.

"A photographer always looks out the window first thing in the morning," he said. "In New York, it was many times murky and grey; in Miami, it was almost always bright and sparkling, and the cloud formations were usually interesting."

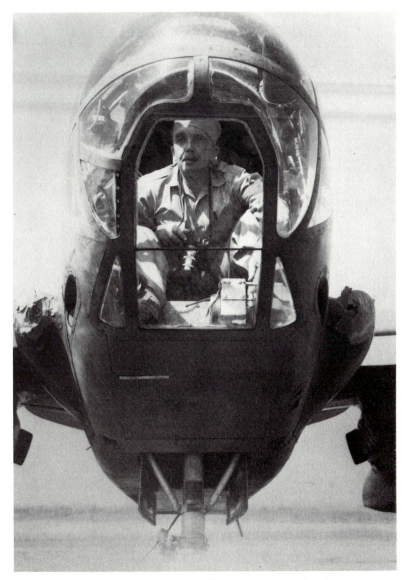

Groenhoff prepares for a flight in a Douglas A-20 during the 1941 Louisiana maneuvers.

Groenhoff returns to the Bahamas after one of his many trips as a "goodwill ambassador."

In Florida, Groenhoff again turned to freelancing, maintaining his excellent professional relationship with the giants of the general aviation industry. Piper, Beech, and Cessna always seemed willing to send their newest, freshly painted aircraft south to be photographed by Groenhoff, with those special Florida clouds always in the background. The resultant brochures and advertisements sustained Groenhoff while he expanded his interests into other fields, writing an occasional piece for the trade magazines on his new love, the Bahamas. Soon, the Bahamas Ministry of Tourism took notice and decided that Groenhoff's unique blend of imagination, drive, and creative talent would be the proper catalyst to promote tourism.

The Bahamas' Flying Treasure Hunt was born. Groenhoff's aerial photographs of the islands and their breathtaking beauty provided opportunity and challenge for the vacationing light-plane pilot and his family to engage in an old-fashioned treasure hunt from the air. With tourism increasing dramatically, Groenhoff and his wife, Fran, moved to the Bahamas in 1966 to become fully involved with the tourist industry. Golf club and tennis racket replaced Contax and Speed Graphic. Flying and soaring still provided their own particular brand of joy and satisfaction, and an occasional Piper would make the long trip from Pennsylvania for a special "sitting." But the days of hanging precariously out the rear cockpit of a Stearman for just one last shot or dangling from the strut of a Taylorcraft in a moment of stark terror were gone—though certainly not forgotten.

Groenhoff greets television personality Arthur Godfrey during one of his frequent trips to the Bahamas in the 1960s.

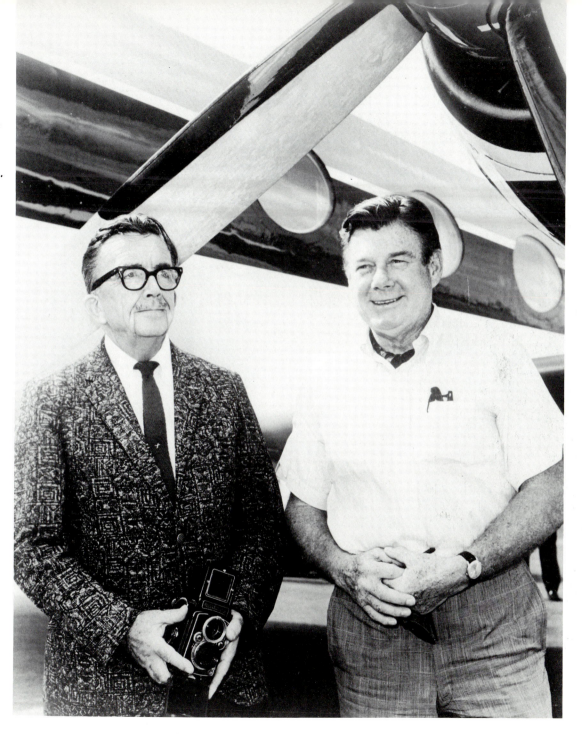

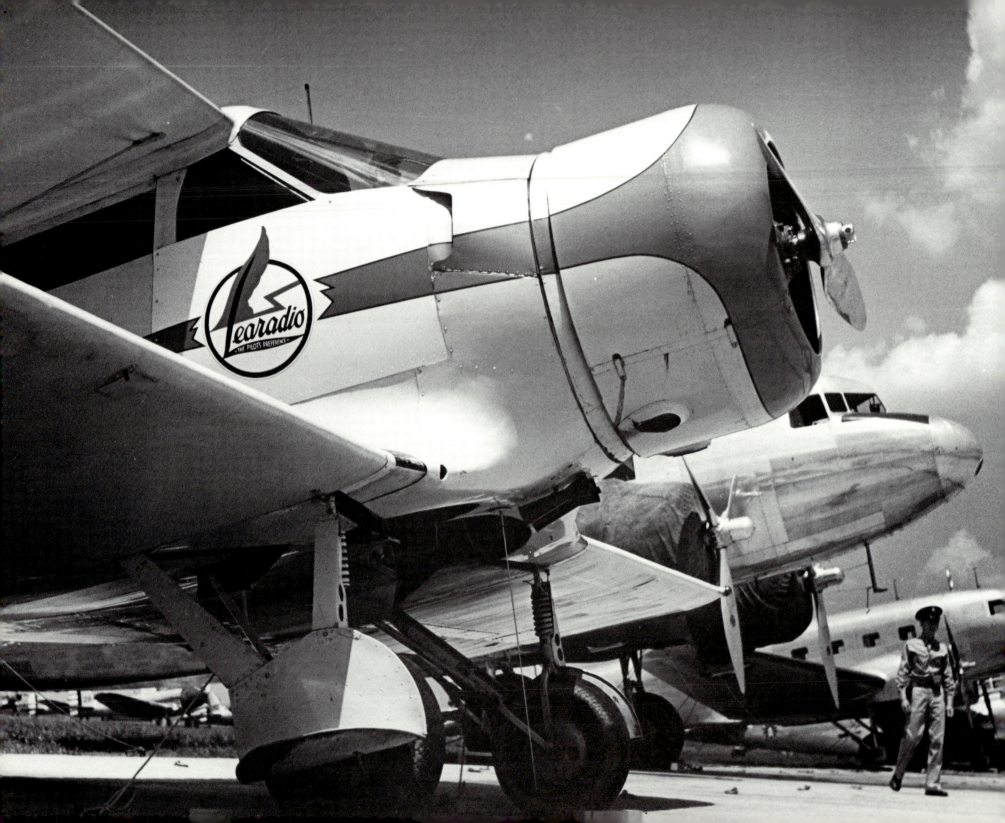

Aircraft
A Different Perspective

Quite often, the composition of a Groenhoff photograph is the single, striking quality that distinguishes it from the work of other aviation photographers of the 1930s and 40s. His unusual combinations of airplanes, people, clouds, and seemingly irrelevant objects are dramatic, eye-catching, and thought-provoking. Groenhoff's rare sense of artistry, love of flying, and absolute mastery of skills and techniques combined to give his work an immediately recognizable style, unmatched in his profession.

"I consider my photography an art form. I tried to put something into the picture instead of just recording something. I tried to do it with one well-prepared and well-composed photograph, and it would satisfy me to take just one shot," he said. Spending several evenings at Miami Airport to catch a jetliner landing and taking off at sunset was a typical enterprise for Groenhoff. "When I finally took it, I knew I had it. You have to get a visual image in your mind

Beechcraft Model 17, c. 1939

and then, when the opportunity comes, especially when you're in the air, you sometimes have to grasp it within a fraction of a second."

In 1941, Groenhoff published his views on the theory and practice of aviation photography in *The Complete Photographer*, a periodical devoted to amateur and professional photography. The series of articles were a distillation, a synthesis of almost ten years of experience in the field and could even serve as a textbook for today's hobbyist or professional. His advice ranged from the specific to the general, and included tips on equipment, techniques, planning, and procedures.

According to Groenhoff, speed and ease of handling photography equipment were of utmost importance. For all practical purposes, a lens of f/4.5 was excellent for flight photography. Groenhoff hardly ever used a telephoto lens because of loss of depth and perspective. Contrary to the public notion that flight photographs must be taken at extremely high shutter speeds, Groenhoff felt that a maximum shutter speed

of 1/200 or 1/250 second was normally adequate. An optical viewfinder, a neck strap, a camera equipped with one or two handles, a lens shade, medium yellow and orange haze filters—all were considered prerequisites for an efficient flight photography mission.

Groenhoff's personal preferences for cameras changed with the times and the circumstances. Beginning with his brother's Erneman Sportsman and Contax 35mm, at one time or another he used almost every type of camera that could conveniently be adapted to unusual working conditions. For large photographs, a rebuilt 4x5 Speed Graphic was used, with a shield around the bellows for protection against the slipstream—"I had to use large size equipment because of color, which in those days only came in large size"; a Combat Graphic, designed for use by the armed forces—"Completely enclosed in a wooden box, it was perfect for me"; a Fairchild aerial camera—"I hardly ever used it because it was not suitable for this type of work"; a Rolleiflex—"A wonderful camera, it had no bellows"; an Eastman Medalist—"A 2¼ x 3¼ roll film camera which was almost ideal for my work. It had an excellent lens and the format was very good and easy to handle. I probably used up five Medalists."

Aircraft with open cockpits were not ideal for his aerial photography, according to Groenhoff. Although he did much of his work from Stearmans, Wacos, and such, he preferred the protection and space afforded by a cabin, and much of Groenhoff's general aviation photographs were taken from the relative comfort of a Piper, Cessna, Beech, or Aeronca. Even a trip on an airliner could offer fine opportunities for beautiful views of clouds. In this instance, Groenhoff cautioned: "Do not be afraid to include parts of the wing in your picture. A wing tip properly placed in relation to the

rest of the picture usually will impart depth to the skyscape and in general, add interest to the photograph."

Groenhoff demonstrates this philosophy in almost every one of his aircraft photographs. His aerial views quite frequently feature struts, wires, or a wing tip to complement the subject aircraft, with the customary cloud in the distance providing a suitable backdrop. In ground views, the subject may be seen through the landing gear of a nearby aircraft, through a chain-link fence, or framed by palm trees. Often, a Taylorcraft, Luscombe, or Boeing 314 will serve as a frame through which to view the Miami skyline, the Warrenton Hunt Races, or the yachts of the wealthy riding leisurely at anchor at Port Washington, New York. Whatever the image, it is one that Groenhoff wished to convey, pre-planned, well conceived, superbly executed, and a delight to behold. In Groenhoff's view, "A plane's function is not to rest peacefully in some corner of a field; it is symbolic of power, of fast action, of adventure, and excitement."

There is, perhaps, one quality above all that separates the work of the average photographer from that of the very few at the pinnacle of the profession. Courage. A word often used lightly. Few of us know whether we have enough until called upon to use it in a special situation. Fortunately, for most, these situations occur infrequently. For Groenhoff, they were a daily occurrence.

Groenhoff must not only have had an unusual amount of courage, but quite frequently, demonstrated a blatant disregard for his own personal safety. In his 1941 essay on aviation photography, he went to great lengths to caution his readers on the safety aspects of flight photography. Keep the safety belt fastened at all times, he advised, to avoid being thrown out in the event of turbulence; wear a parachute when making close-ups of airplanes in flight; do not ask the

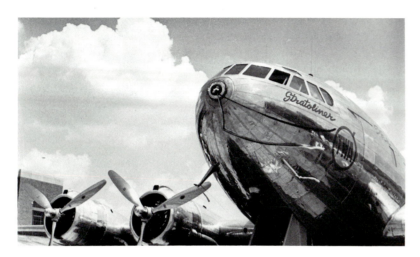

Boeing SA-307B Stratoliner, c. 1940. The Stratoliner, the first commercial transport with a pressurized cabin, entered service with TWA in 1940.

pilots to fly in too close a formation; prepare and arrange your equipment in the aircraft before it takes to the air; and lastly, do not ask for spectacular and dangerous maneuvers for the sake of one unusual picture.

In practice, Groenhoff rarely flew with restraints while actually engaged in the business of photographing another aircraft in the air. Often, he would remove the door from an airplane, such as a Piper or Cessna. "Sitting sideways with the feet dangling out, you had no choice but to fly without a safety belt!" Afforded an unobstructed view of his subject, Groenhoff held on by the seat of his pants, and "I suppose, by grabbing the side of the airplane!" Once, while taking pictures of a new Taylorcraft, his aircraft hit a down-draft while cruising in formation at several thousand feet

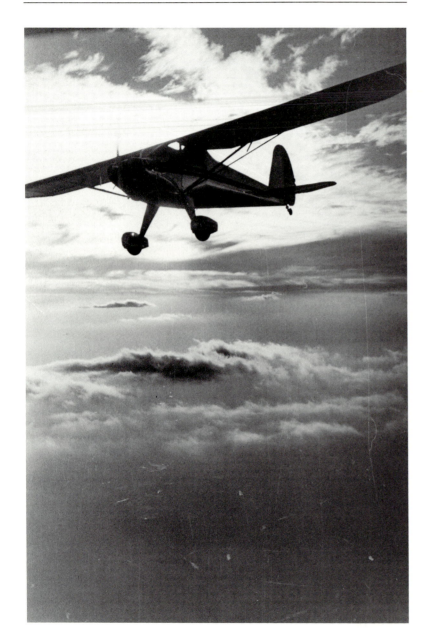

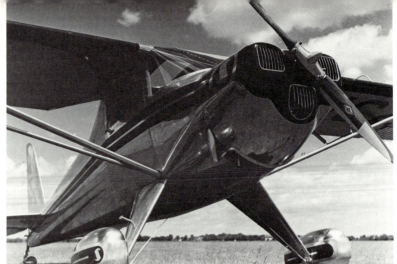

Luscombe Model 8-D Silvaire, 1941.
Featuring all-metal construction, except for a
fabric-covered wing, the beautiful Silvaire was a
popular favorite of the sportsman pilot.

over New York City. From his accustomed position, seated in the doorway, untethered and unencumbered by a parachute, Groenhoff was thrown out of the airplane.

"I landed outside on the struts, grabbed one with one hand, grabbed the side of the open door with the other. The pilot reached out and grabbed me by the collar of my jacket and pulled me back in again!"

Groenhoff is proud of the fact that in this, and many other similar incidents, he never lost a camera. His standing instructions to his wife were to be sure to develop the film if he ever fell to his death, because he would be taking pictures all the way down! Narrow escapes of this nature were a routine and acceptable part of Groenhoff's professional life. Standing in the rear cockpit of a Waco biplane or an army A-17, or climbing down onto the float of a seaplane "because the float gets into your view" were not foolhardy stunts or idle demonstrations of bravado; they were merely rather obvious, rather routine tricks of the trade for a professional on top of his craft.

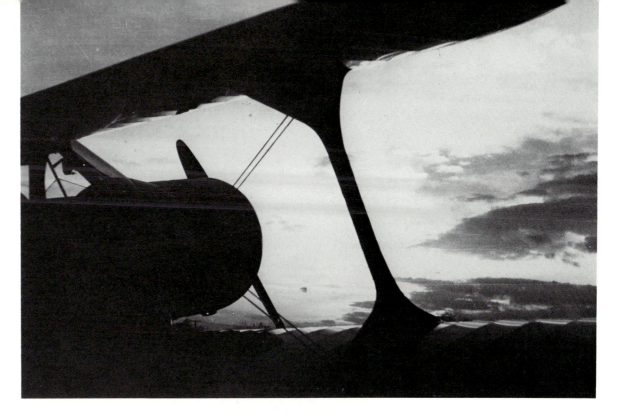

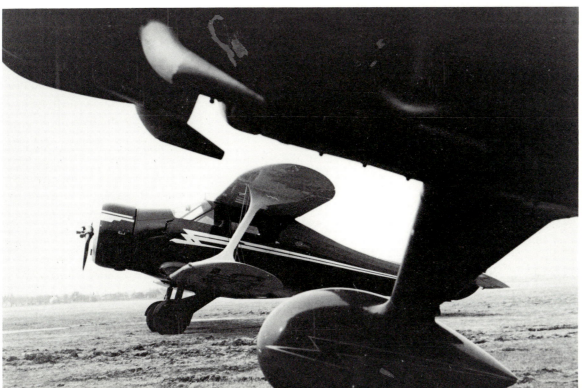

*Beechcraft Model 17, c. 1939.
The fastest personal and
executive transport of its day,
the Staggerwing still ranks
as a favorite with the
discriminating sports pilot
after half a century of service.*

Curtiss Condor, c. 1936. The lumbering Curtiss Condor, the last biplane to be used by the airlines of America in the early 1930s, was the first transport airplane to be fitted with bunk beds.

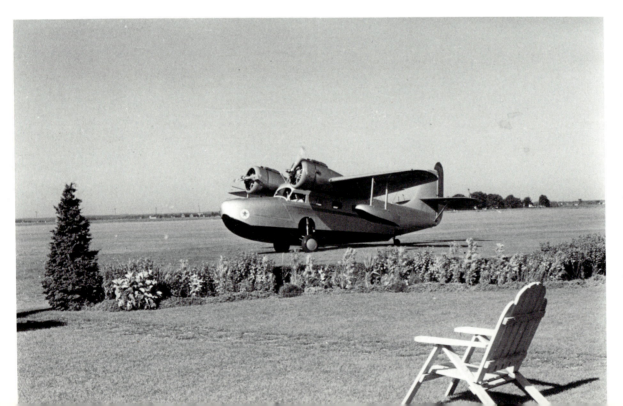

Grumman G.21, Aviation Country Club, c. 1939. A popular feature of annual air shows at the Aviation Country Club of Long Island was the demonstration of current aircraft for the discriminating private owner, without the usual attendant "sensational" aviation activities.

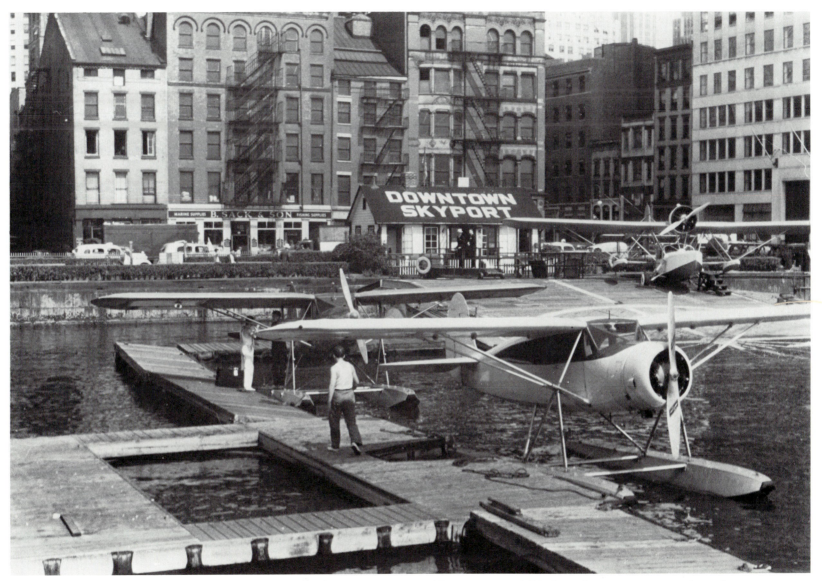

Fairchild Model 24-G, Wall Street Seaplane Base, New York City, 1938. This busy base was a convenient site for bankers and stockbrokers commuting mainly from Long Island to their offices in Manhattan.

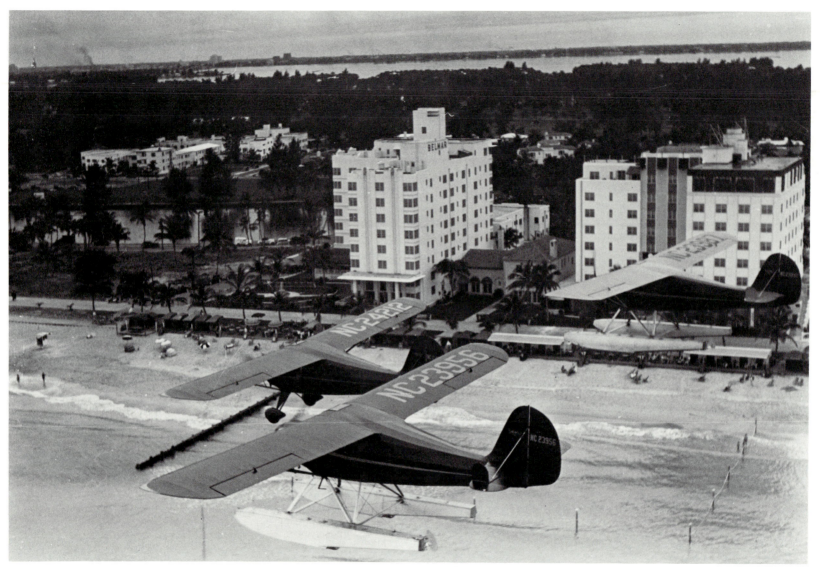

Aeronca Chief 50Fs, Miami, 1938. Biscayne Bay and the Miami skyline were familiar and welcome landmarks at the end of the annual migration of light planes, many of them sporting the latest Edo-designed streamlined pontoons.

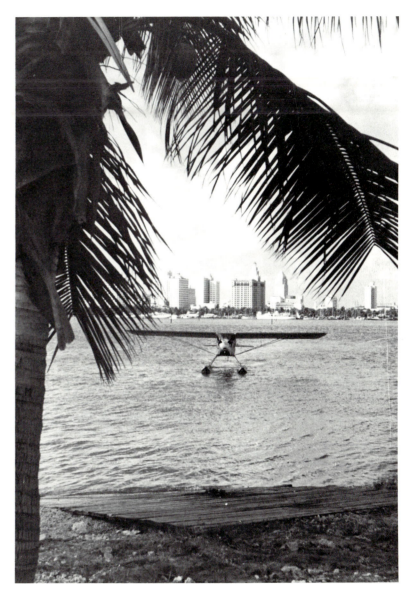

Taylorcraft BL-65,
Miami, 1937.

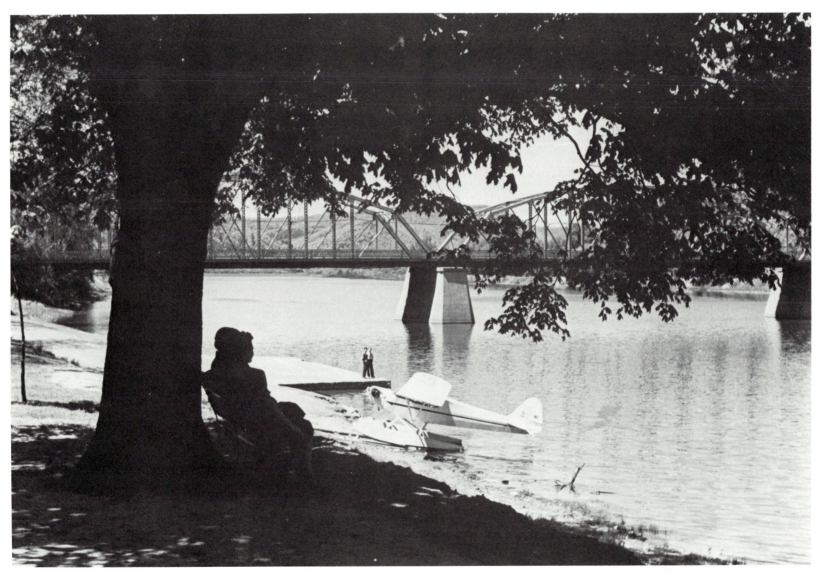

*Piper J-3 Cub, Lock Haven, Pennsylvania, c. 1939. The popular Cub rests in an idyllic setting
on the shore of the Susquehanna River near the Piper factory at Lock Haven.*

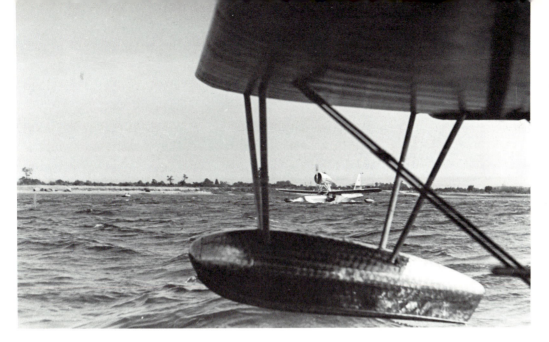

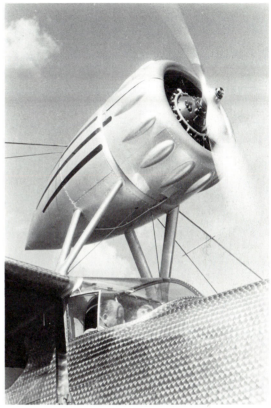

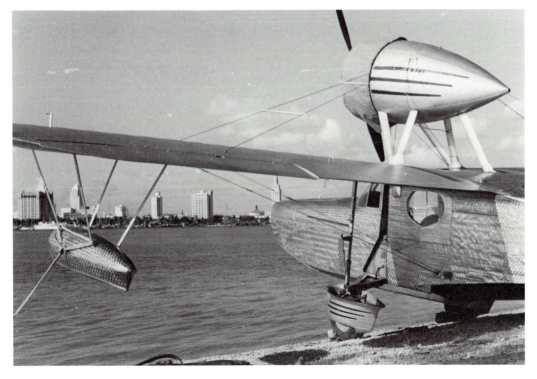

Fleetwing Seabird, Miami Seaplane Base, 1937. The ungainly Seabird pioneered the use of shot-welded stainless steel construction and advertised a performance equal to that of a comparable landplane, despite the handicap of hull and engine nacelle design.

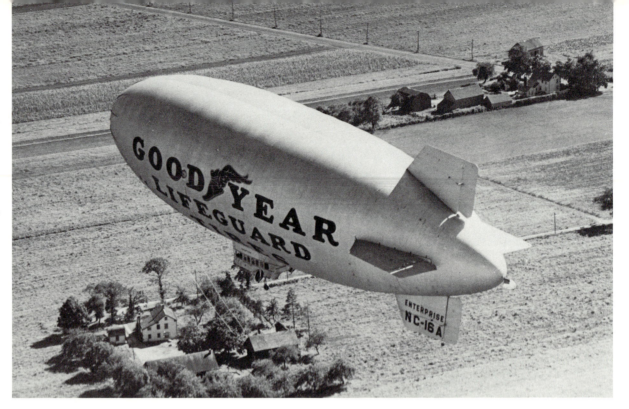

Goodyear Blimp Enterprise, *1938.* Enterprise *and her sisterships in the Goodyear fleet of blimps were familiar sights as they roamed over the country serving as "ambassadors of the sky," demonstrating lighter-than-air capabilities to the American public.*

Hindenburg, *Lakehurst, New Jersey, 1936. Last of the German rigid airships, the* Hindenburg *lands after one of her ten scheduled round trips between Germany and the United States in the summer of 1936.*

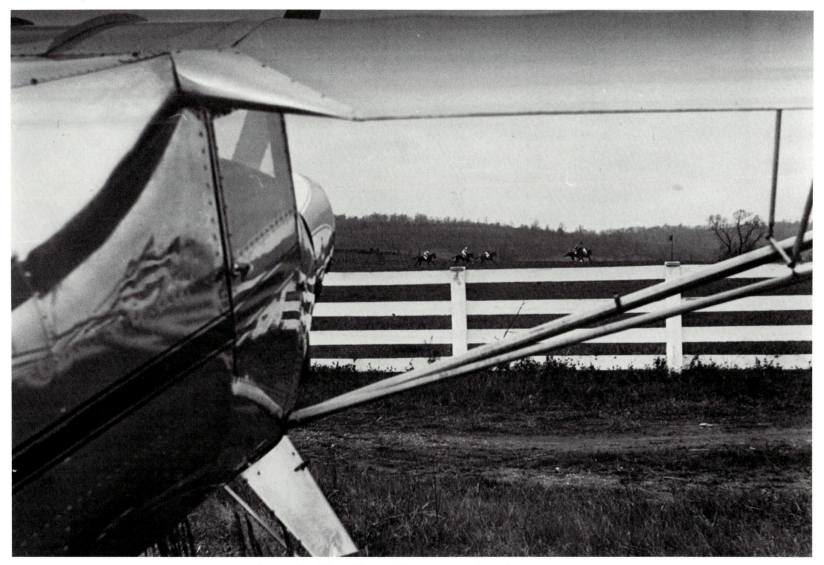

Luscombe, Hunt Races, Warrenton, Virginia, c. 1938.
Groenhoff flew this shiny Luscombe to Warrenton to dramatize the superiority of the airplane's cross-country
performance over that of the "creeping, earthbound" automobile.

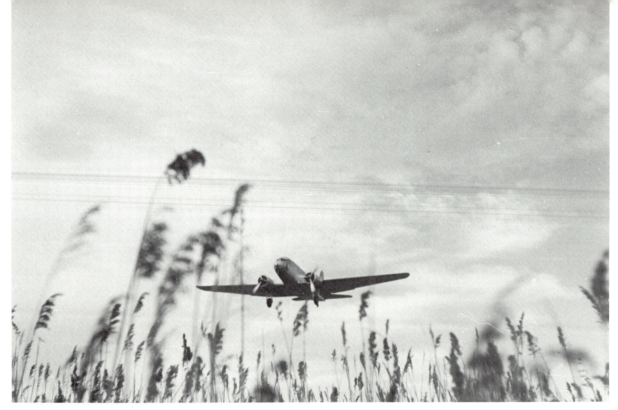

Douglas DC-3s, Newark Airport, New Jersey, 1937. Coast-to-coast overnight service at more than 200 mph was TWA's proud claim for the Douglas DC-3, which by December 7, 1941, would make up 80 percent of the airliners on U.S. domestic scheduled services.

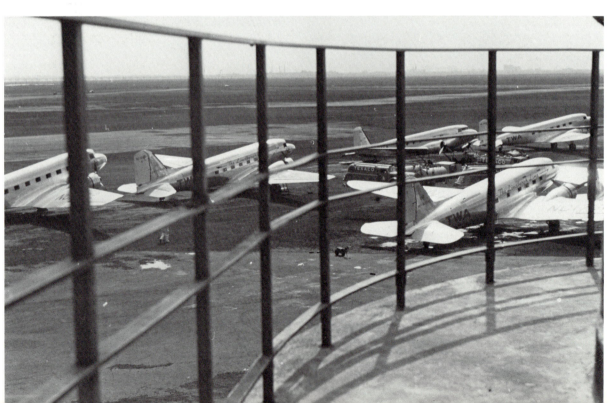

Grumman G.21 Goose, c. 1939. Grumman amphibians bound for the Peruvian Air Force attest to the adaptability of the little flying boat, popular for decades with executive and military pilots alike, and still flying today.

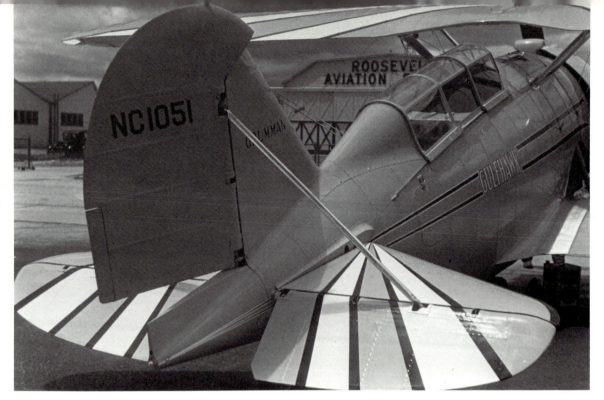

Grumman G.22 Gulfhawk III. The Gulfhawk III was a two-seat variant of the Gulfhawk II used by Al Williams for executive travel in the interests of Gulf Oil.

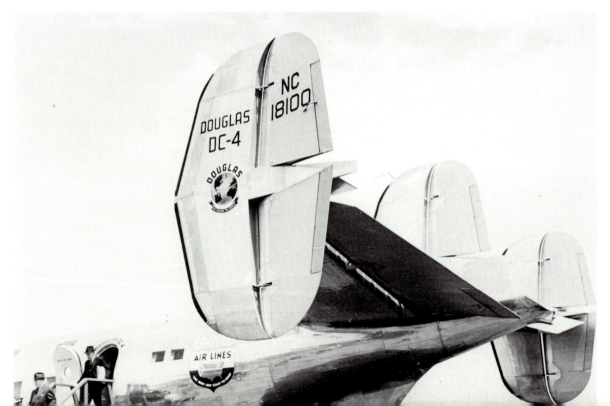

Douglas DC-4E Prototype, 1939. The unusual triple tail of the complex and expensive DC-4E eventually disappeared as the design was refined, and the legendary DC-4 evolved to give dependable service to the world's airlines for over 40 years.

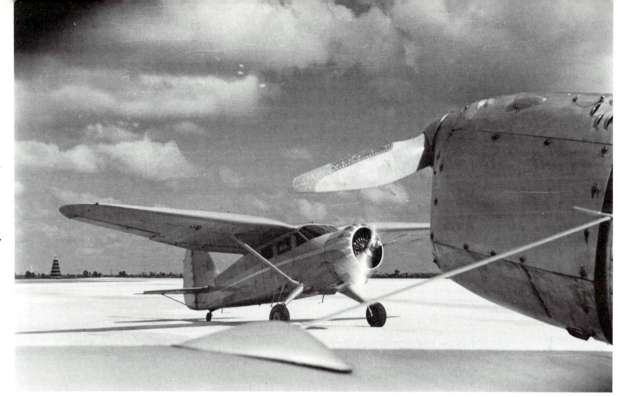

Stinson SR-9 Reliant (background), Ryan S-T (foreground), c. 1939. The most elegant of the long line of Stinson cabin monoplanes, the Stinson Reliant is viewed here over the cowling of the sleek Ryan S-T.

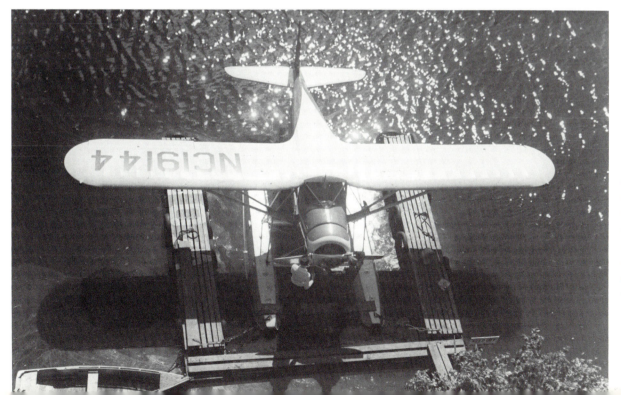

Fairchild 24, Schuylkill River, Pennsylvania, 1938. As seaplane operations from lakes, rivers, and other sheltered water areas became popular, more businessmen-flyers commuted to work from their own one-man seaplane bases.

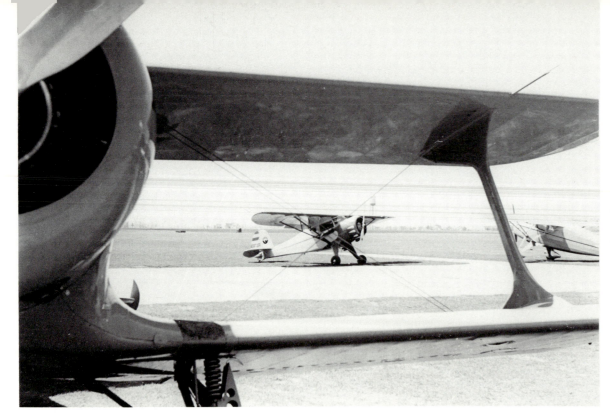

Beechcraft Model 17 (foreground), Monocoupe 90A (background), Fairchild 24 (right). Each a classic in its own right, these popular light planes set standards of excellence for the sportsman pilot of the 1930s.

Aeronca "L," 1939. Dwarfed by the mammoth DC-4E transport, the distinctive Aeronca "L" was a distant cousin of the highly successful Aeronca C-2s and C-3s of the early 1930s.

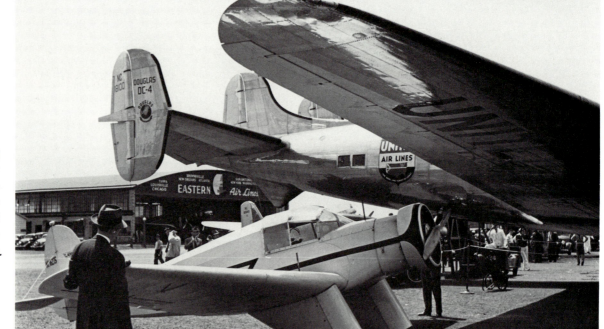

Sikorsky S-43, 1939. This luxuriously-furnished "aerial yacht," owned by William K. Vanderbilt, was used extensively for business and pleasure flying throughout the Caribbean and South America.

Luscombe Model 90, Aviation Country Club, Long Island, c. 1938. Groenhoff's unique sense of timing and flair for the unusual are evident in this dramatic shot.

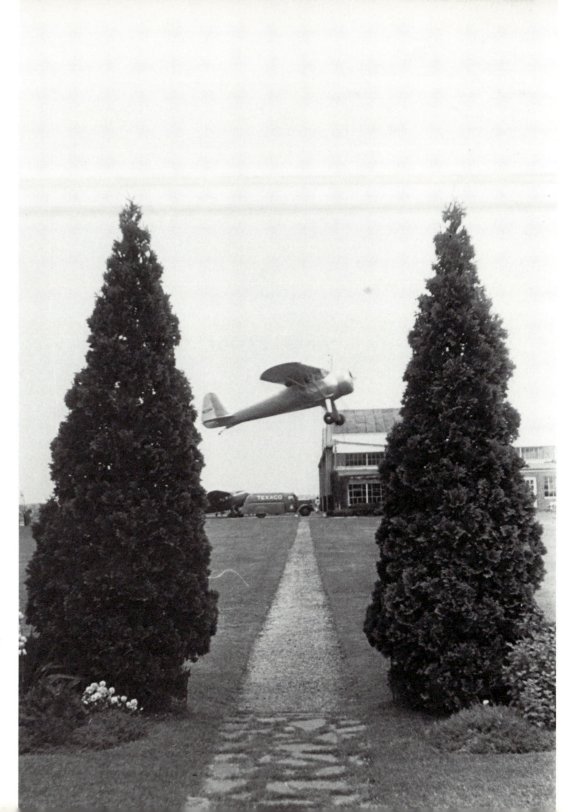

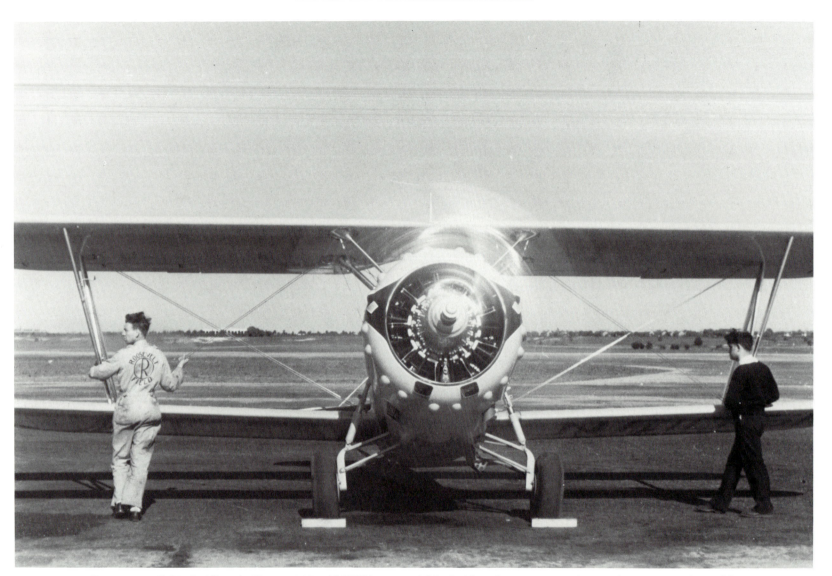

Grumman G.22 Gulfhawk II, c. 1938. Al Williams and his Gulfhawk prepare to depart from Roosevelt Field for one of his regular performances on the air show circuit in the 1930s.

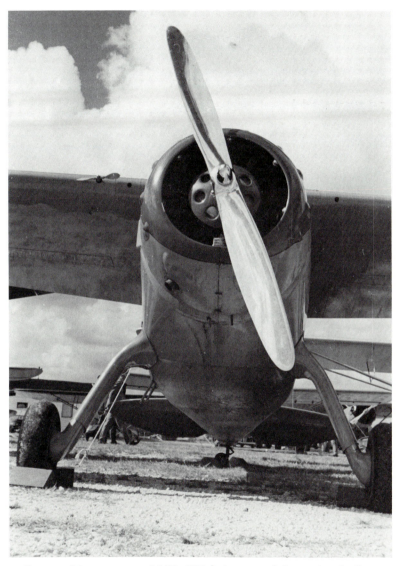

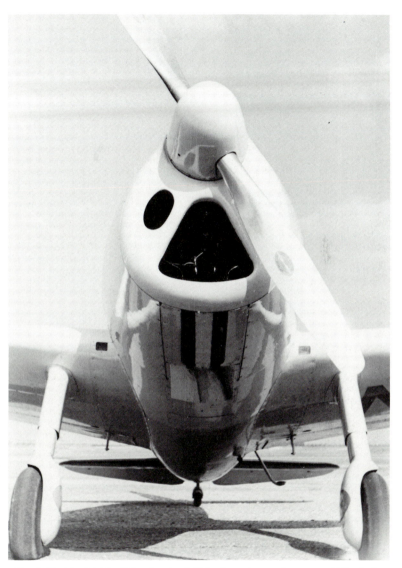

Cessna Airmaster, c. 1938. With its graceful yet simple lines, the Airmaster delivered a performance comparable with modern products of the 1980s.

Clark F-46, 1939. The brainchild of engineer-inventor Virginius E. Clark, the experimental F-46 was constructed mainly of wood and plastics using Clark's patented Duramold process.

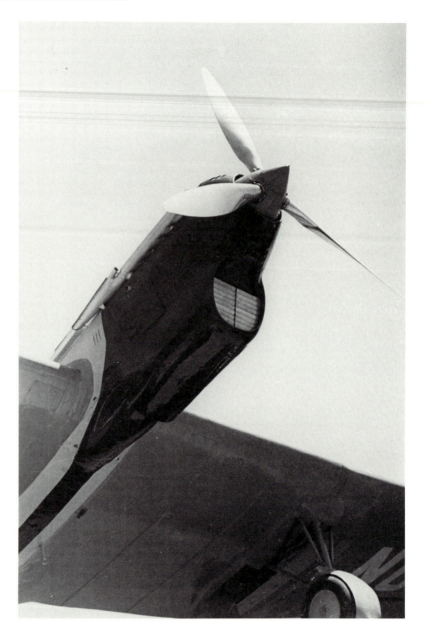

Tupolev ANT-25, 1937. Designed specially for distance flying, this remarkable aircraft flew from Moscow, U.S.S.R., to San Jacinto, California, in a little over 62 hours, establishing a new world's nonstop distance record of 6,295.6 miles.

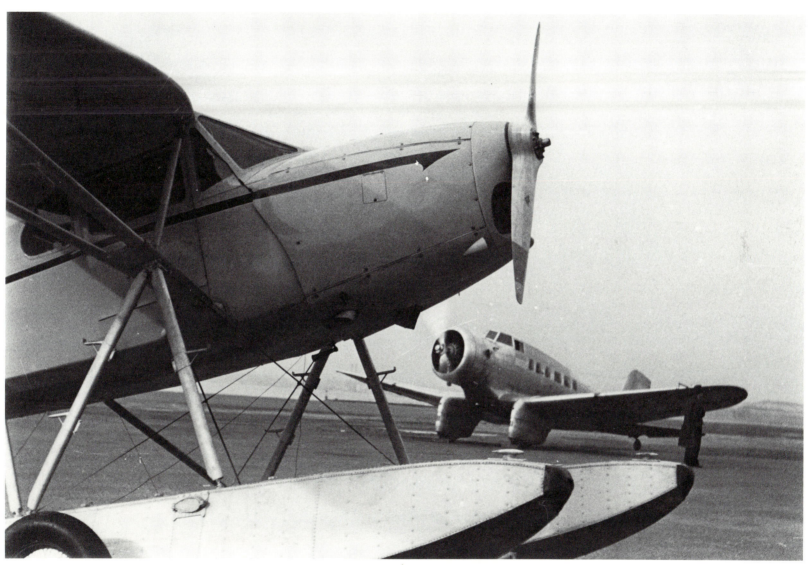

Fairchild Model 24 (foreground), Northrop Delta 1-D (background), c. 1937. Easily one of the most popular light planes with sportsmen, business executives, and commercial operators, the Fairchild Model 24 makes an unusual frame for one of John K. Northrop's classic all-metal low-wing monoplanes of the 1930s.

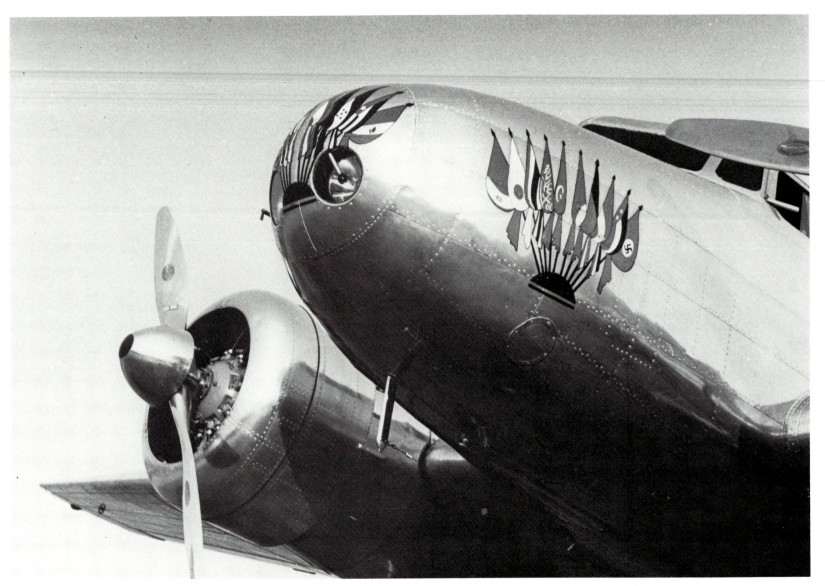

Lockheed 10 Electra, 1939. The Electra's speed, safety, and general efficiency made it highly attractive for personal and corporate use, as well as for commercial airlines.

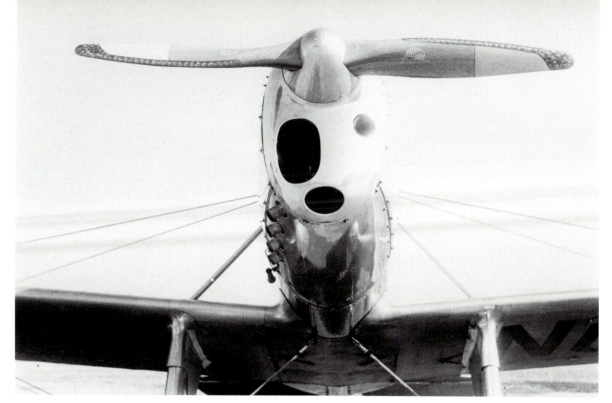

Ryan S-T, 1939. This striking, open-cockpit aircraft, always a center of attraction at air shows around the United States, was the first low-wing trainer used by the Army Air Corps.

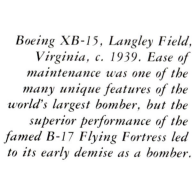

Boeing XB-15, Langley Field, Virginia, c. 1939. Ease of maintenance was one of the many unique features of the world's largest bomber, but the superior performance of the famed B-17 Flying Fortress led to its early demise as a bomber.

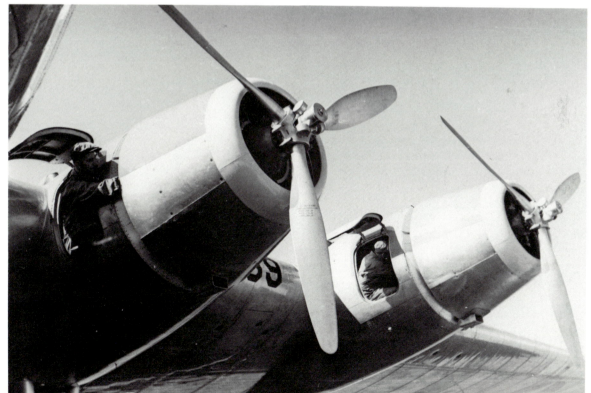

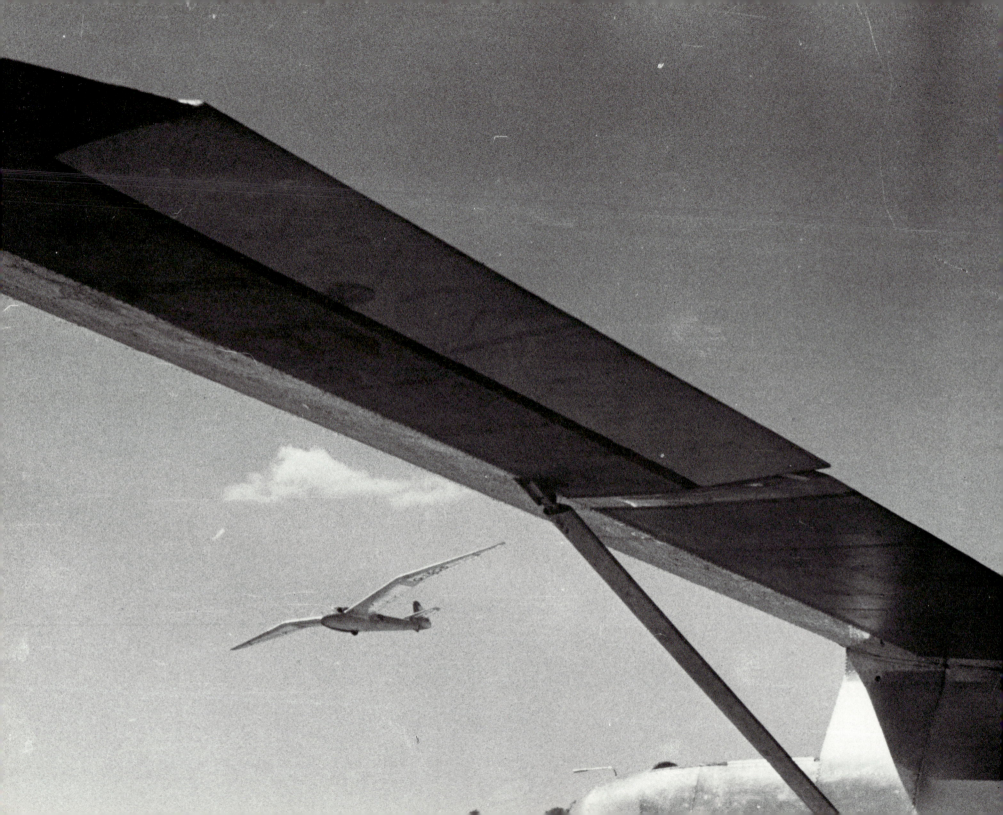

Motorless Flight
Gliding in the Early Days

For many young aspiring aviators in Germany in the 1920s and 1930s, flying started on the Wasserkuppe, a desolate plateau nestled in the Rhön Mountains. Immediately after World War I, aviation activity was severely limited in Germany under the terms of the Treaty of Versailles. Thus, motorless flight was a convenient and practical outlet for the energies of schoolboys, sportsmen, and many survivors of the dogfights over France and Germany. Postwar activities began in earnest with the world's first glider meeting in the Rhön Mountains in 1920. Lilienthal and Chanute gliders, even motorless relics from the air war, provided the platforms for the first tentative, exploratory flights by newcomers to the sport. As the pilots gained experience, designs improved, and performance records began to fall regularly. Within a few short years a natural transition was made from the less demanding downhill glider to the more intricate, and dangerous, art of soaring.

Schweizer SGU 1-6, 1937

At age 16, Groenhoff made his first trip to the Wasserkuppe. Under the guidance of his more experienced younger brother Günther, he began a lifelong love affair with sailplanes, soaring, and clouds, although soaring would eventually take second place to his passion for aviation photography. Memories of the exciting and challenging times on the Wasserkuppe were still fresh in Groenhoff's mind when he disembarked from the *New York* in 1927, and later as he studied his *One Thousand Words in English* and struggled to earn a living in the big city. News of the German glider movement and the remarkable soaring records that were being established in Europe followed Groenhoff to the United States. Aside from some sporadic interest, however, little activity occurred there until 1928, when several visiting German pilots gave soaring demonstrations with the latest German equipment. An unofficial American soaring endurance record of slightly more than four hours was set. W. Hawley Bowlus designed, built, and flew the first real American sailplane in the same year. A glider school, the

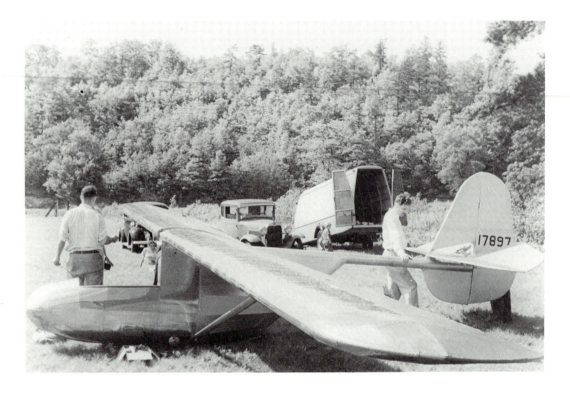

Schweizer SGU 1-6, in the Catskills, 1937. Ernest and Paul Schweizer designed and built this first all-metal glider. Later on, they founded Schweizer Aircraft Corporation. (This page and opposite.)

American Motorless Aviation Corporation, sprung up in 1929. The first soaring flight of any significant distance was made by Dr. W. B. Klemperer. With the idea of organizing and promoting gliding and soaring as a sport, the National Glider Association was formed in 1929. With such prominent personalities as Eddie Rickenbacker, Amelia Earhart, and Admiral Moffett lending their support and advice, plans were made for the "First National Gliding and Soaring Contest," to be held in 1930. The hills of the Chemung Valley near Elmira, New York, were chosen as the location for the first meet. The choice was indeed fortuitous; with the subsequent organization of the Soaring Society of America in

1932, the advantages of the many ridges and soaring slopes around Elmira eventually made it the natural center for soaring sport in America.

Groenhoff faithfully chronicled the annual soaring meets at Elmira and in the Catskills, photographing the Americans and the more experienced pilots visiting from Europe with their high performance sailplanes. He also called upon his own personal experience as a glider pilot, and his considerable skill as a writer, to cover the meets as a correspondent for *The Sportsman Pilot* and other aviation periodicals. His articles and striking photographs trace the evolution of soaring in America: pioneers of the sport, such as Richard du Pont,

Warren Eaton, Ralph Barnaby, Hawley Bowlus, and others; elegant, graceful aircraft with curious names such as Minimoa, Rhönsperber, Albatross, and Zanonia.

Groenhoff's dual career as professional photographer and pilot was highlighted by occasional but unforgettable episodes, some of which occurred during his gliding days. As frightening as many of them were, Groenhoff remembers even the close calls with a certain nostalgia.

They were freewheeling days before the war. The FAA officials were old-time flyers themselves, and I think they managed to look the other way, smile, and get a kick out of it themselves. I had a crash once. I crashed in a glider in the Catskill Mountains of New York. I was flying a sailplane in the up currents that go off the slope of the mountain. When you do that, you go back and forth along the mountainside just for the fun of it, and the wind rises on the slope and supports your flight. I had a sailplane which had been restored after a crash by an aviation school in New York. I found out later on that the skin on the wing had been put on too tightly from the trailing edge of the wing to the aileron. When the skin is tight, the aileron is restricted, so I flew along this mountainside, and all of a sudden I found myself in the down current instead of the up current. I was just about treetop (height) and wanted to turn away, and because of this restriction in the aileron,

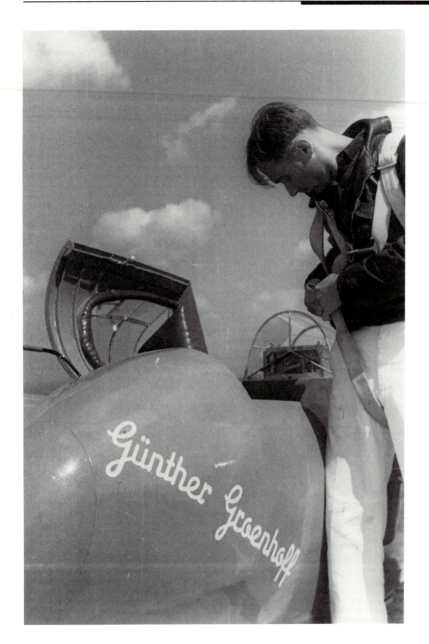

Emil Lehecka and Rhönsperber
Sailplane, Elmira, 1934.
Lehecka flew this high
performance sailplane to
the U.S. National Soaring
Championship in 1938.
(This page and opposite.)

I couldn't turn steep enough and went into the trees. Both wings came off, and I went over vertically in-between the trees. I saw the ground coming up, and I said to myself, "Well, this is it!" and then, of course, I didn't remember anything and sometime later, I woke up in the clearing and there was a railroad track which was about 400 yards downhill from where I crashed.

I never knew that I crawled down this. I must have crawled down unconsciously or subconsciously, and they finally picked me up from the track. It is interesting what you think and what you do in a case like that.

Those days at Elmira and the Catskill Mountains of New York were happy and exciting times for Groenhoff, reminiscent of the times spent on the Wasserkuppe with Günther. This was still the era of stick and rag sailplanes. The aroma of beechwood and birch, glue and doped fabric—distinctive, lovely smells—would eventually be replaced by the pungent odors of epoxy and gellcoat. By modern standards, the sailplanes of the early 1930s were primitive; performance was poor and cockpits were uncomfortable. Nonetheless, the formative years of gliding in America had an unmistakable charm. Groenhoff captured this distinctive ambience in his incomparable black-and-white photographs of the personalities, the aircraft, and the beautiful hills and valleys of New York State.

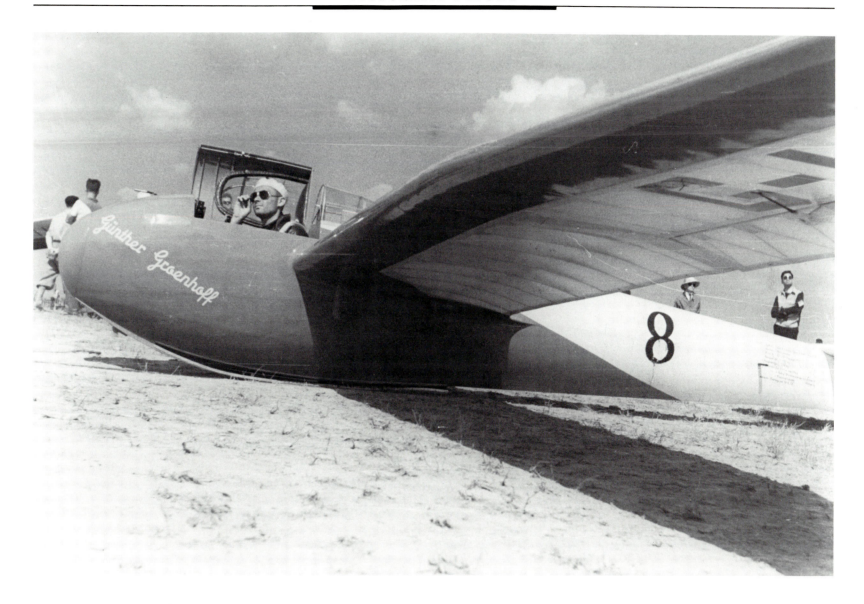

Richard du Pont (in parachute) and Göppingen Go.3 Minimoa, Elmira, 1937. Richard du Pont, who contributed the prestige of his family name as well as his uncommon skill as a pilot to the American gliding movement, held the national soaring title for five successive years.

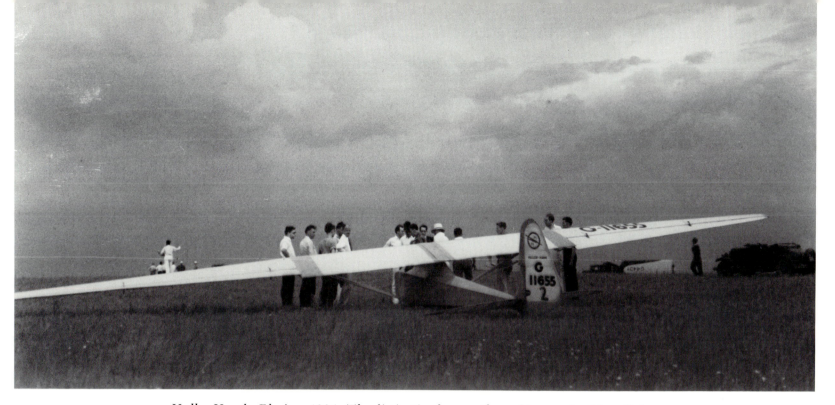

Haller Hawk, Elmira, 1934. The distinctive logo on the rudder marks this sailplane as a product of the Haller-Hirth Company.

Kirby Kite Sailplane, Elmira, 1940. The distinctive gull-winged sailplane is moved into position for launch on Harris Hill, center of the soaring activities near Elmira.

Göppingen Go.3 Minimoa, Elmira, New York, 1937. Gliding and soaring sites near Elmira became so popular that the area became known as the "Wasserkuppe of America."

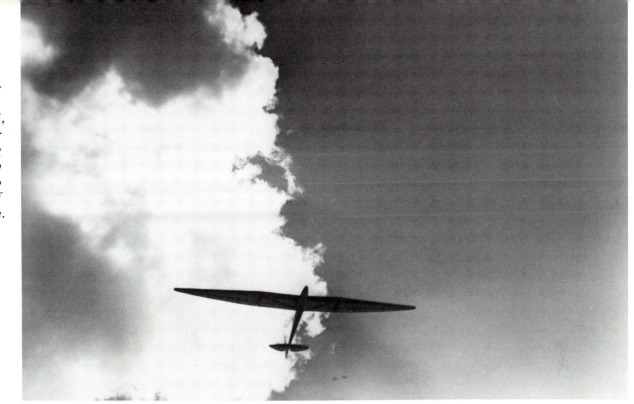

Du Pont-Bowlus Albatross II, Elmira, 1935. Designer Hawley Bowlus, a pioneering glider specialist, joined with Richard du Pont to manufacture gliders of distinctive design.

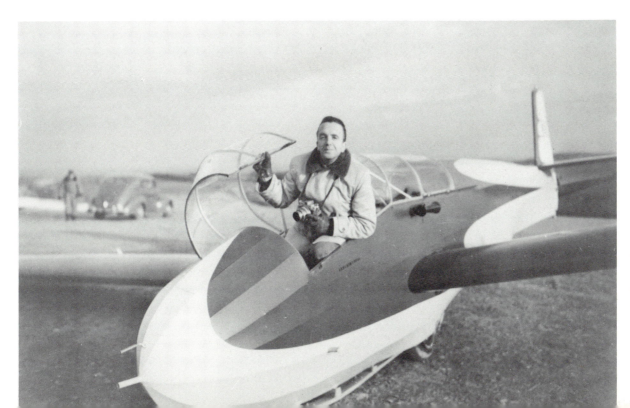

Hans Groenhoff, Elmira, 1934. Groenhoff was a regular and enthusiastic participant in the Elmira gliding meets, as pilot, journalist, and official photographer.

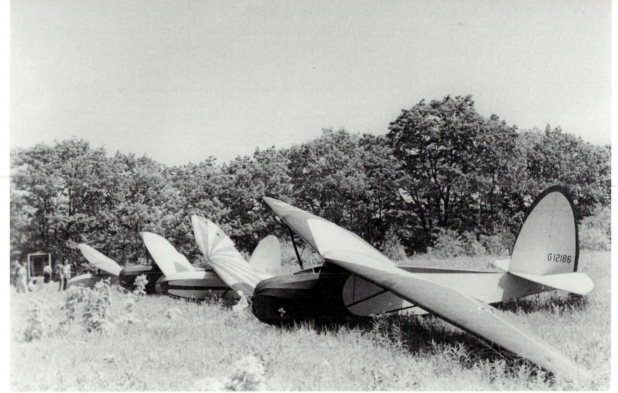

Elmira, New York, c. 1937. Caught during a lull in the activities at Elmira, these sailplanes show the graceful lines and simplicity of design which had a direct influence on the design of many small aircraft in the United States during the 1930s. (left to right) Göppingen Go. 1 Wolf, Franklin PS-2, Göppingen Go. 1 Wolf, SU-1.

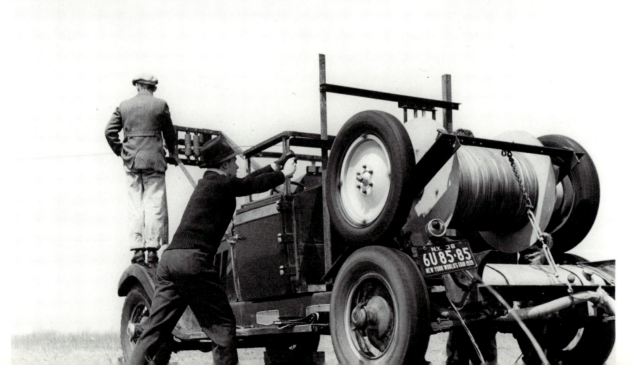

Glider launching winch, Elmira, c. 1937. This winch, mounted on the rear of an automobile, was used to launch gliders off Harris Hill near Elmira.

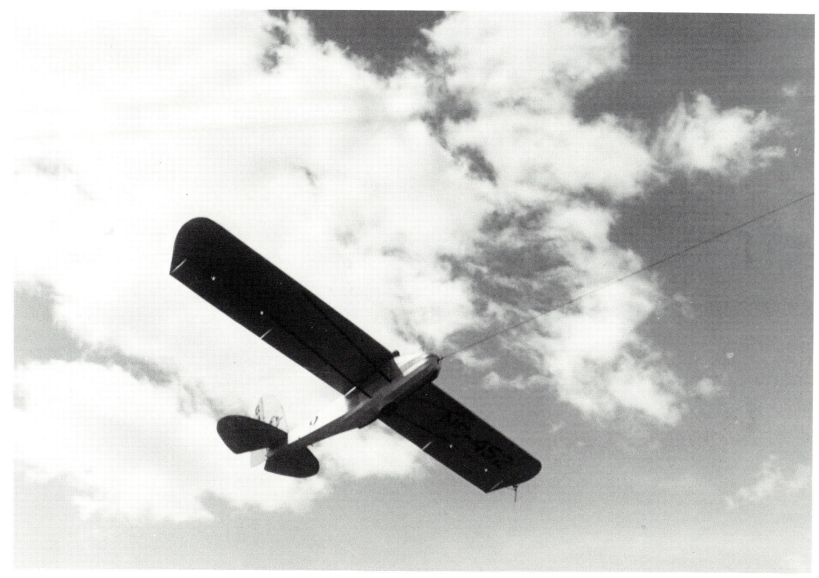

Franklin PS-2, Elmira, 1934. An outgrowth of Frank Hawk's Texaco "Eaglet," in which he was towed coast-to-coast, the PS-2 won the U.S. National Soaring Championship at Elmira in 1930, 1931, and 1933.

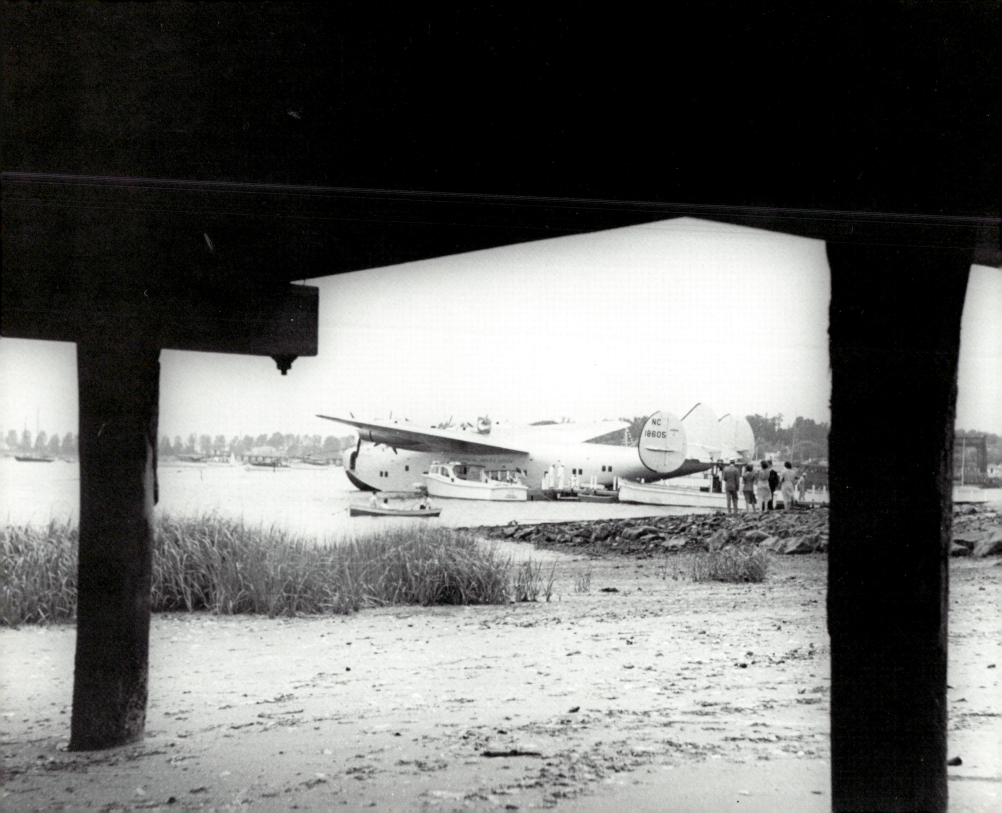

Atlantic Conquest

In the 1930s, few developments in the field of commercial air transportation captured the public imagination as much as the elegant and majestic flying boats. Port Washington, situated on the north shore of Long Island, not far from New York City, was the principal base for transatlantic seaplane operations between the United States and Europe until it was replaced by the new seaplane terminal at La Guardia Field in 1940. At Port Washington, Groenhoff was fortunate enough to capture the color and flavor of this bygone era, as the United States, Great Britain, and Germany, each in its own distinctive way, attempted to establish safe and economical commercial flying across the North Atlantic.

As early as 1930, the Germans introduced transatlantic airmail service by using a combination of fast ocean liners and aircraft. Two special mail-carrying float planes, designated Junkers-Ju 46, were carried

Pan American Airways Boeing 314 Dixie Clipper, *Port Washington, 1939*

aboard the Norddeutscher Lloyd liners *Europa* and *Bremen* during their transatlantic runs to the United States. About 700 miles east of New York, the mail plane was launched by catapult from the liner and flew on ahead to land on the Hudson River and deliver its precious cargo of mail. Enterprising though the plan was, it proved to be impractical and saved insufficient time to make a significant impact on the mail services as a whole. The opportunistic Groenhoff was often on the scene to photograph the liner *Europa* as she rendezvoused with her mail plane after docking at New York City.

As the United States and Great Britain made careful preparations to initiate experimental transatlantic mail flights, the Germans continued their attempts to develop more effective combinations of catapult ship and seaplane. Beginning in 1936 with the converted steamer *Schwabenland* and Dornier Wal flying boats, Deutsche Lufthansa launched the mail planes on trial runs from the Azores to Port Washington. A series of eight successful flights

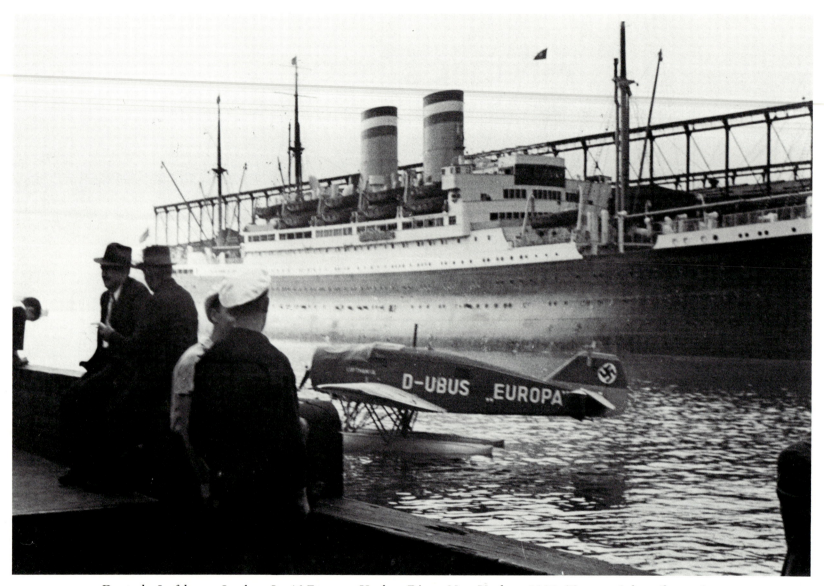

Deutsche Lufthansa Junkers-Ju 46 Europa, *Hudson River, New York, c. 1935. Two special mail-carrying floatplanes were carried aboard the Norddeutscher Lloyd liners* Bremen *and* Europa.

Pan American Airways Terminal, Port Washington, New York, c. 1936. Port Washington, on Long Island Sound, a few miles east of New York City, was the U.S. center for intercontinental flying boat operations during the late 1930s.

were made, to be followed in 1937 by additional trials using the larger, four-engined float plane, the Blohm and Voss Ha 139. Two of these aircraft, the *Nordwind* and the *Nordmeer*, operating from the depot ships *Friesenland* in the Azores and *Schwabenland* in Long Island Sound, flew seven round-trip flights between August and November 1937. In 1938, the flights continued, with a third aircraft, the *Nordstein*, added. During one of the visits of the *Nordwind*, Groenhoff and other members of the New York press were invited aboard the *Schwabenland* as it rode at anchor in Long Island Sound. Groenhoff came away from the visit with a series of historic photographs of the fascinating diesel-powered *Nordwind* and

its mother ship. But he shared a strong suspicion with his fellow reporters that the entire operation was merely a cover for German attempts to develop some sort of open ocean military capability. In any event, the Azores–New York trials ceased after 1938, and the three aircraft were shifted to operations in the South Atlantic. Groenhoff's photographs remain as a unique glimpse of this unusual, little-remembered chapter in the story of transatlantic flight.

The British also were faced with the problem of launching aircraft with a much larger load than would be possible for a normal water takeoff. As the famous Short "Empire Class" S.23 flying boats were undergoing development be-

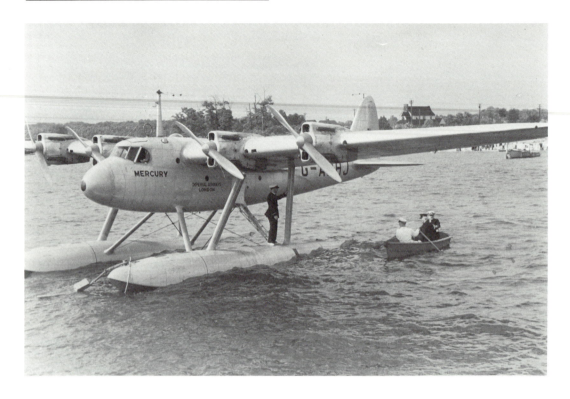

fore their introduction on the North Atlantic run, a truly remarkable approach to the problem was taken by British designer Major R. H. Mayo. Mayo reasoned that a large flying boat, such as one similar to the S.23 Empire Boat, could carry a smaller aircraft piggyback part of the way across the ocean before casting it loose toward its destination—in this case, the United States. The advantage of this rather unusual scheme was that at the time of separation, the upper component could be launched at cruising altitude with a full load of fuel and a weight of cargo or mail that would have made a takeoff from water impossible.

Major Mayo's brilliant concept came to fruition in the remarkable *Mercury-Maia* combination. *Mercury*, the sleek, beautifully conceived twin float seaplane could increase its normal gross takeoff weight from 12,500 pounds to 20,500 pounds when air-launched from *Maia*, the large, rather sedate mother ship. Revolutionary though Mayo's concept was, it was a technical, if not a practical or economic, success. Separation tests of the two aircraft began in February 1938, followed in July by the first attempt to cross the Atlantic. The elegant *Mercury* carried 600 pounds of freight and mail from Ireland to Montreal in a little over 20 hours. *Mercury* completed her momentous journey by continuing on to Port Washington, where the ever-present Groenhoff awaited. Again,

Imperial Airways Short S.20 Mercury, Port Washington, 1938. In 1938, Mercury flew nonstop from Foynes, Ireland, to Montreal, Canada, in just over 20 hours. (This page and opposite.)

he was in position to record a truly remarkable event in the history of air transportation.

Despite the impressive initial success of the Mayo composite concept, the British did not follow up on the remarkable accomplishment. *Mercury* was limited to the role of occasional mail carrier, and by 1939, the capability for transatlantic passenger service was on hand. After two years of proving flights by the Pan American Airways Sikorsky S-42B *Clipper IIIB* and the Imperial Airways Short Empire boat *Caledonia*, Pan American's Juan Trippe initiated the first sustained transatlantic scheduled passenger service with the most luxurious flying machines of their day, the Boeing 314 Clipper ships. The Boeing Clippers began weekly service to France and England in June 1939, departing from New York, with Baltimore as an alternate terminus during the winter months. British efforts to develop sufficient performance from the Empire boats to operate a comparable service failed, as war came to the North Atlantic. Soon, the Empire boats would be drafted for military service with the Royal Air Force. The three German Blohm and Voss catapult aircraft of Deutsche Lufthansa also saw wartime duty as the Luftwaffe adapted them for use in reconnaissance and minelaying roles. Eventually, as the United States was drawn into the war, even the majestic Boeing Clippers were pressed into service as military transports.

In many of his photographs of the commercial flying boat operations at Port Washington, Groenhoff was able to incorporate the daily activity at Port Washington for his own purposes with considerable effect. During the 1930s, the community had developed into the foremost private seaplane base in the eastern United States. Owners of float planes and amphibians, many of them members of the Sportsman Pilots Association, departed from their permanent base at Port Washington for seaplane cruises to points as distant as the Virgin Islands in the Caribbean. Many wealthy Long Island residents commuted regularly in their Aeroncas, Fairchilds, and Grumman amphibians to the Wall Street Seaplane Base in New York City.

Hundreds of boats also dotted the scene. Sailboats, the magnificent mahogany and steel cabin cruisers of the affluent, even an occasional three-masted sailing schooner of ancient vintage, were frequent counterpoints to the Empire boats riding at anchor, the Boeing Clippers loading their passengers for the long trip to Europe, or the *Nordwind* squatting on the *Schwabenland's* catapult. The era that Groenhoff captured on film was romantic, fascinating, and all too transitory.

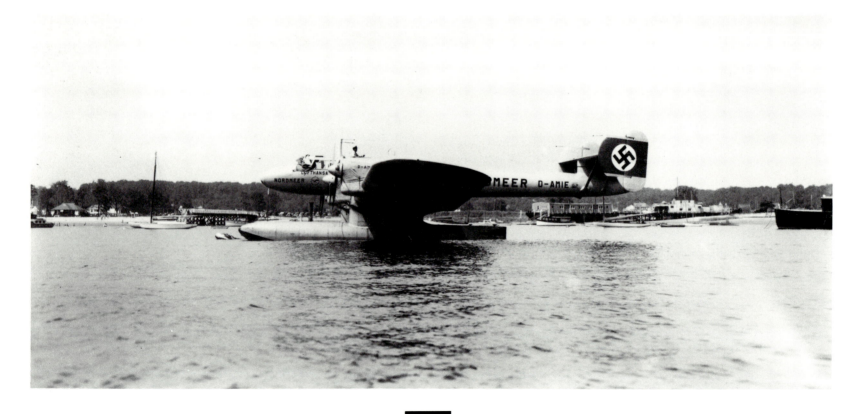

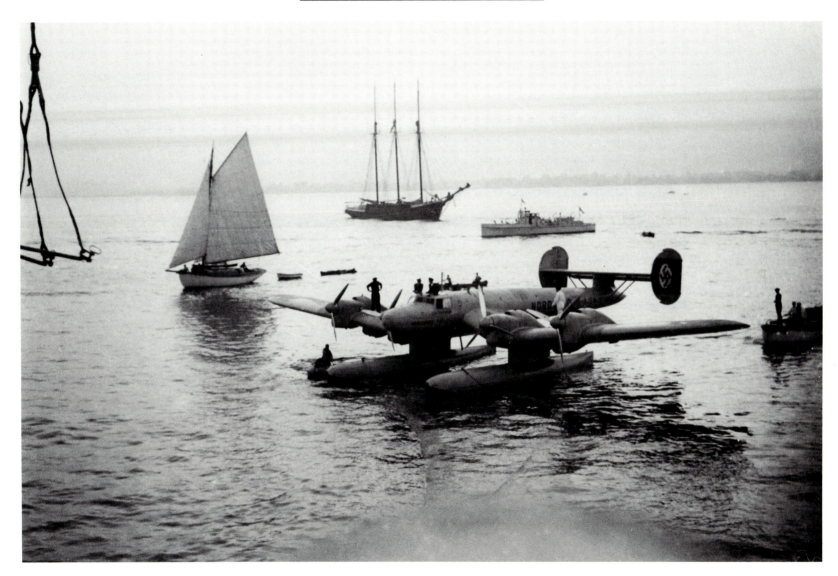

Deutsche Lufthansa Blohm und Voss Ha 139 Nordmeer, *Port Washington, 1938. Operating from the depot ships* Schwabenland *or* Friesenland, *based in the Azores,* Nordmeer *and* Nordwind *made seven experimental round trip flights between the Azores and Port Washington in 1937. (This page and opposite.)*

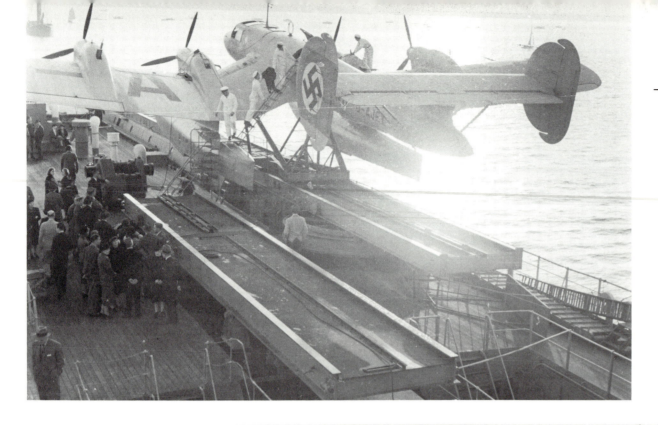

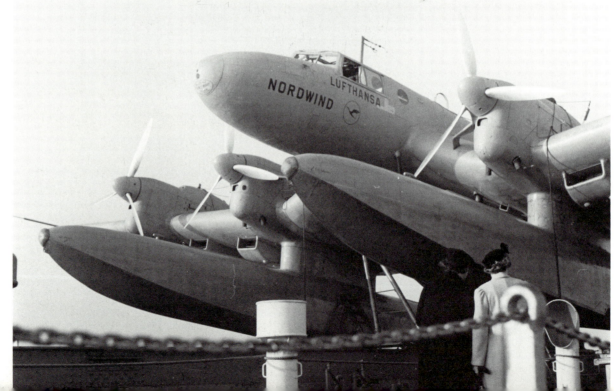

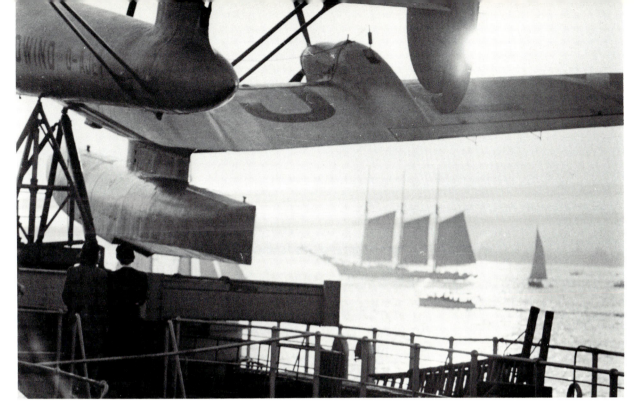

Deutsche Lufthansa Blohm und Voss Ha 139 Nordwind, *aboard* Schwabenland, *Port Washington, 1938.* Nordwind, Nordmeer, *and* Nordstern *together flew 20 round trips between the Azores and Port Washington during 1937 and 1938.* (This page and opposite.)

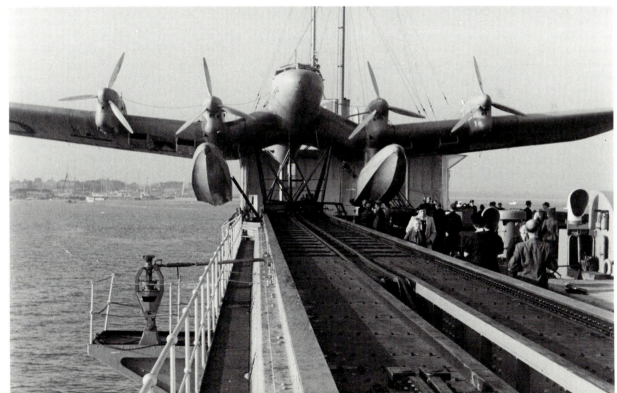

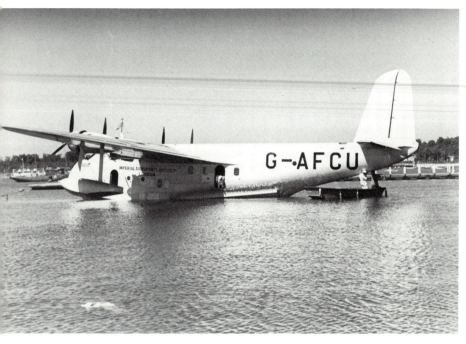

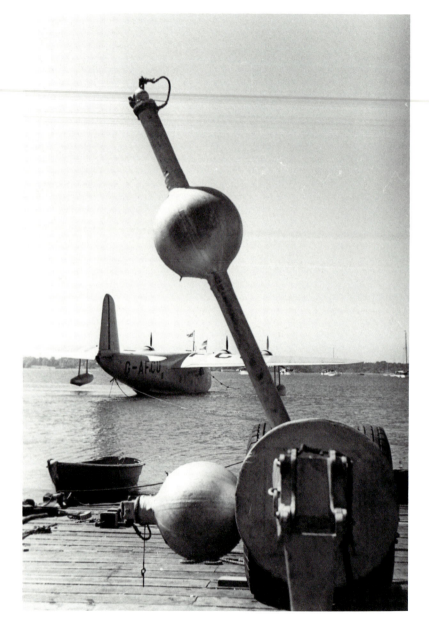

*Imperial Airways Short S.30
Cabot, Port Washington, 1939.
Cabot and her sistership
Caribou made eight North
Atlantic round-trip mail
service trips for Imperial
Airways between August 8 and
September 30, 1939.*

Pan American Airways Seaplane Base, Dinner Key, Florida, 1937. For many years in the 1930s, Dinner Key was one of the outstanding air passenger terminals in the United States.

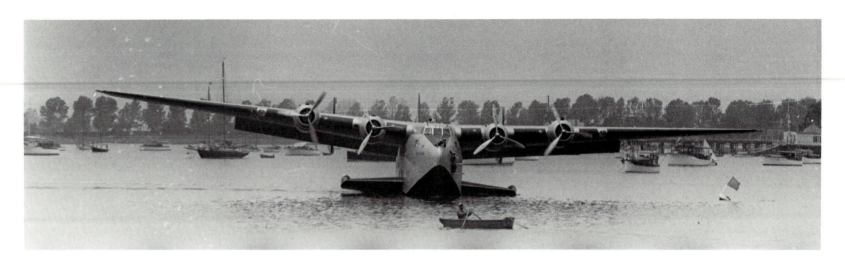

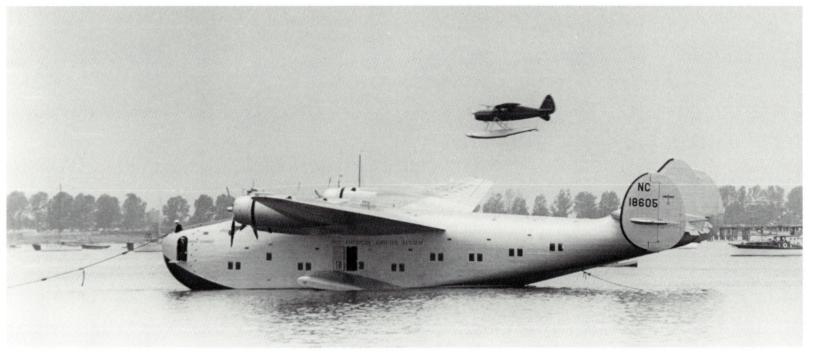

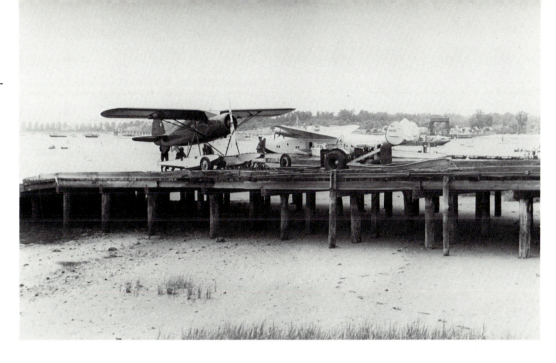

Pan American Airways Boeing 314 Dixie Clipper, *Port Washington, 1939. The magnificent Boeing Clippers surpassed all rivals in size, capacity, and performance.* (This page and opposite.)

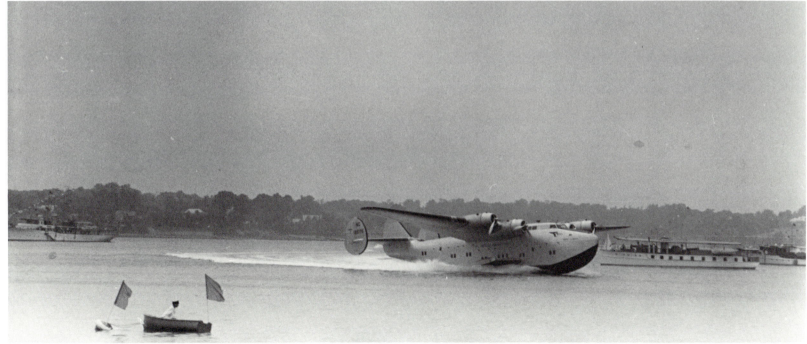

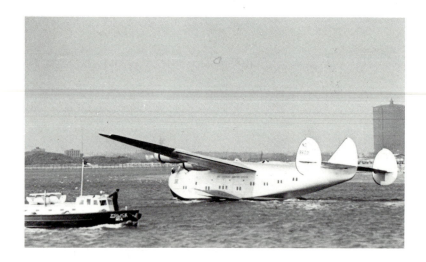

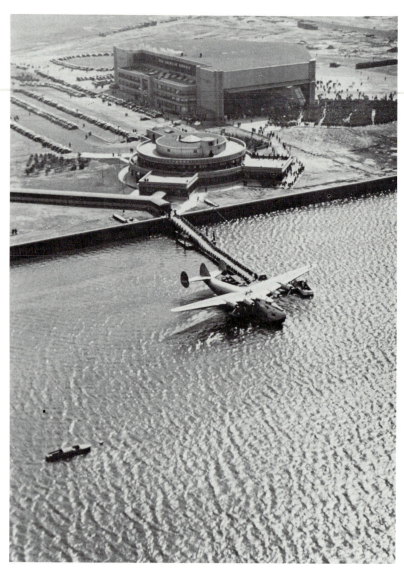

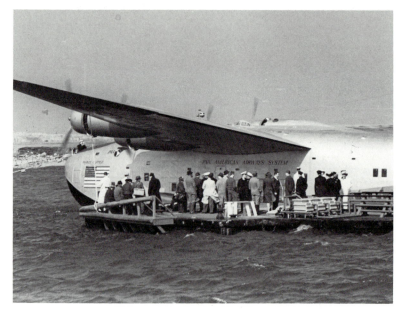

Pan American Airways Boeing 314 Yankee Clipper, LaGuardia Marine Air Terminal, New York, 1940.
Yankee Clipper was christened by Mrs. Franklin D. Roosevelt on March 3, 1939, in New York.

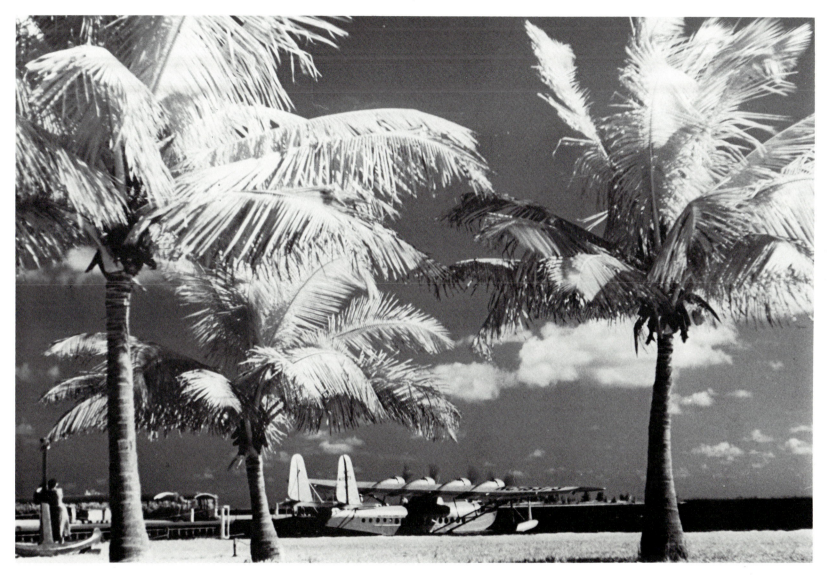

Pan American Airways Sikorsky S-42A Jamaica Clipper, *Dinner Key, 1937.*
The S-42 first entered scheduled service on the Miami–Rio de Janeiro route in August 1934.

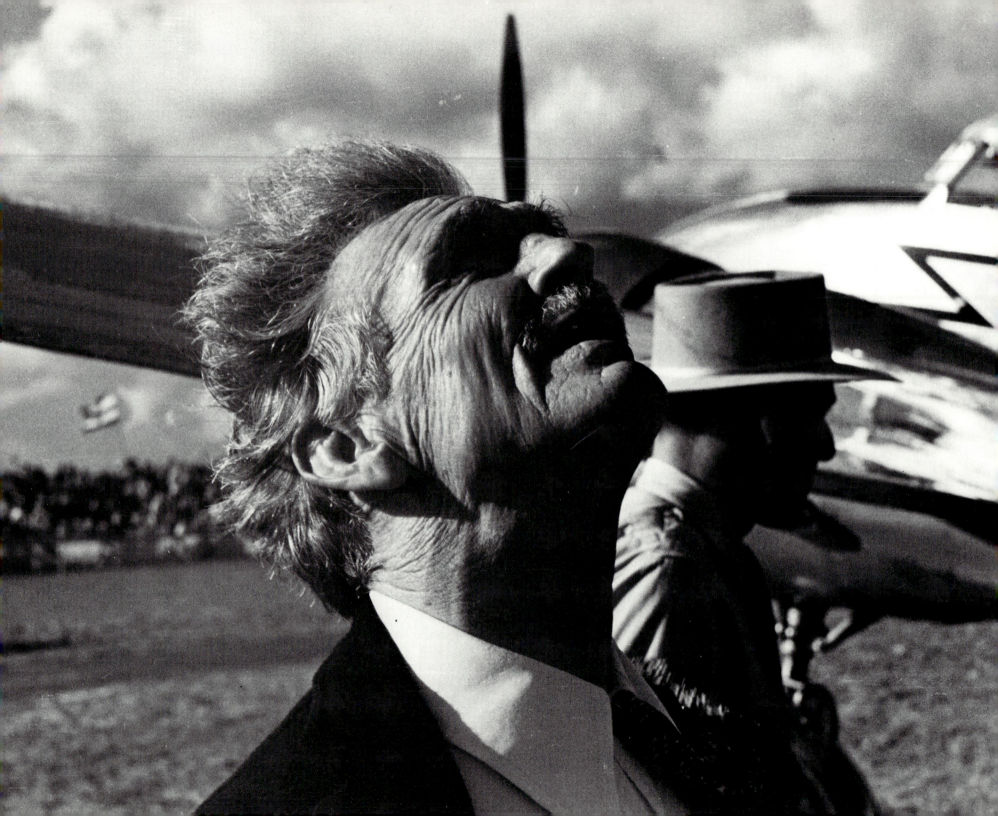

A Day at the Air Races

Any gathering of aircraft had an unusual fascination for Groenhoff. Airports, fly-ins, reunions, conventions—any aviation activity that brought airplanes and aviators together for business or recreation, often brought Groenhoff to the scene, as pilot, photographer, and spectator. He once said, "Photography is a part of me—as much as my ears, the shape of my nose, everything else. But then—so is flying itself!" One event satisfied this basic conviction and provided Groenhoff with unprecedented opportunities to savor and record the essence of sport aviation—the airshow.

Since the first air race was held in 1909 at Rheims, France, the affairs had evolved into major spectacles of entertainment. As the races and their attendant exhibitions and aerial demonstrations were developed in the 1920s, and later organized, modified, and expanded into their present format, the American public was attracted in millions by the drama and the showmanship, the excitement of seeing the flamboyant Roscoe

Bernarr Macfadden, Miami
All American Air Maneuvers, c. 1938

Turner and Gilmore the lion, or the thrill of watching Al Williams perform a dazzling series of aerobatics in his orange and white *Gulfhawk*. Under the inspired leadership of Cliff Henderson, managing director, the National Air Races matured in the 1930s into an annual event that guaranteed spectacular performance and shattered records.

For Groenhoff, the Nationals at Cleveland and the All American Air Maneuvers in Miami offered everything he could possibly wish for. The aerobatic teams, wing walkers, pylon races, parachute jumps, skywriting, all were opportunities for "photos by Groenhoff" for the next edition of *Flying and Popular Aviation* or *Aero Digest*. A major airshow brought all of the leading aviation personalities of the era to one central stage at the same time, where they would not only perform their aerial wizardry, but would gladly share their camaraderie, their stories, and even their airplanes with the photographer and fellow aviator they had all come to like and respect over the years.

Thus, the legendary aerobatic pilot Beverly "Bevo"

Howard would put his Fairchild 22 through its paces while Groenhoff—riding without a safety belt—photographed his facial expressions from the other cockpit. The swashbuckling dandy Roscoe Turner, replete with powder blue uniform, boots, and waxed handlebar mustache would permit Groenhoff to "babysit" Gilmore, the then full-grown lion, in his hotel room while Turner momentarily excused himself—as a joke. Even the spectators would often afford unexpected opportunities for a photograph, and a long term friendship might develop as a result of a chance meeting at Cleveland or Miami. A smiling Duke of Windsor arrived from the Bahamas for the Miami Air Maneuvers; health cultist and publisher Bernarr Macfadden gazed at the aerial displays overhead; "Smilin' Jack" creator Zack Mosley posed by his aircraft. Few could resist having their picture taken by the affable Hans Groenhoff, a celebrity in his own right.

The performers and personalities were indeed desirable, even necessary, subjects for the Groenhoff coverage of the annual airshows. But the essential elements to complete the treatment were the airplanes themselves, whether parked in the hangar awaiting the next day's activities, poised on the flight line awaiting the next event, or swooping through daring maneuvers overhead. A hangar full of the likes of Al Williams's *Gulfhawk*, Joe Mackey's Waco Taperwing, Len Povey's Curtiss Hawk, Rudy Kling's *Folkerts Special*, Tex Rankin's Great Lakes, and Steve Wittman's *Chief Oshkosh*, all at one time, challenged even the imagination of Groenhoff.

It was not enough for Groenhoff routinely to film the spectacular sights and events of the airshow. The urge to participate, the challenge to film the unusual, frequently overrode any inclination, however small, on Groenhoff's part to take the conventional approach. On one occasion, at the annual Miami All American Air Maneuvers, Groenhoff had observed the performance of a Stearman biplane that performed a series of aerobatics with a woman standing on the top wing, secured by a safety belt of some kind. Intrigued by the operation, Groenhoff decided that a rare photograph indeed would result if a camera could be taken along on one of the performances. Naturally reluctant to entrust his cameras to anyone, Groenhoff took what for him was the obvious course. He convinced an incredulous pilot to allow him to ride the wing on the next flight. The pilot showed Groenhoff the single pole on top of the wing, and the safety belt which would secure him to it. With his trusty Medalist dangling around his neck, Groenhoff strapped himself to the pole. The pilot started the engine and taxied out to the runway, and Groenhoff prepared himself for an exhilarating new experience. The takeoff roll was uneventful, but as flying speed was reached, and the airplane lifted off, so did Groenhoff. "My feet took off behind me, because the pilot hadn't told me that the people who fly on top tie their feet to the wing. So I was flying like an angel on top of the rig with my feet dangling out of the thing backwards, held on only by the belt."

Like dozens of other similar escapades, the incident ended rather peacefully, and once again the resourceful Groenhoff not only acquired a remarkable series of aviation photographs, but enhanced his reputation in spectacular fashion.

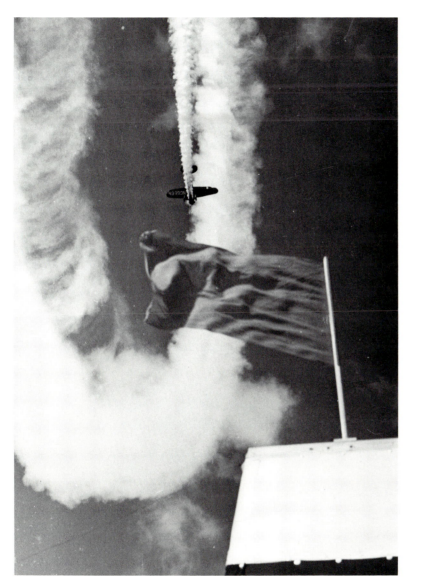

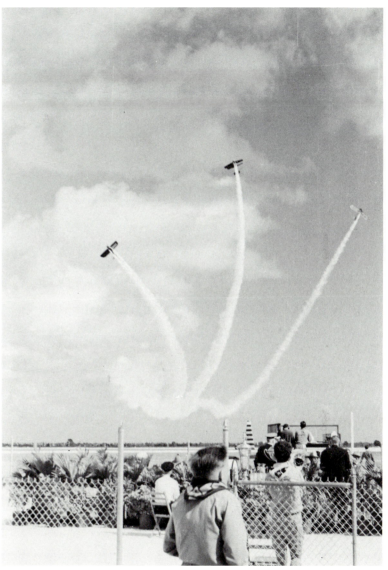

Aerobatics, Miami All American Air Maneuvers, 1936. Highlights of any air show were the aerobatic demonstrations by such legendary pilots as Al Williams, Beverly Howard, and Alex Papana.

Curtiss P-36 Fly-by, National Air Races, 1939. This formation of Army Air Corps P-36s from Selfridge Field, Michigan, was one of the events of the demonstration flying done by the armed services at Cleveland.

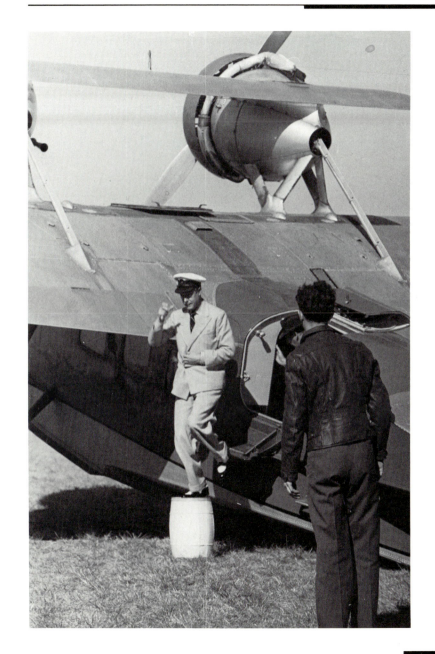

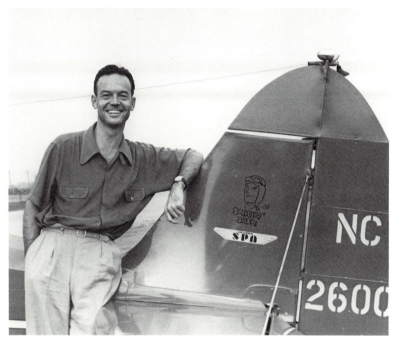

His Royal Highness the Duke of Windsor and Smilin' Jack cartoonist Zach Mosley were among the thousands of participants and spectators attracted to the annual Miami All American Air Maneuvers.

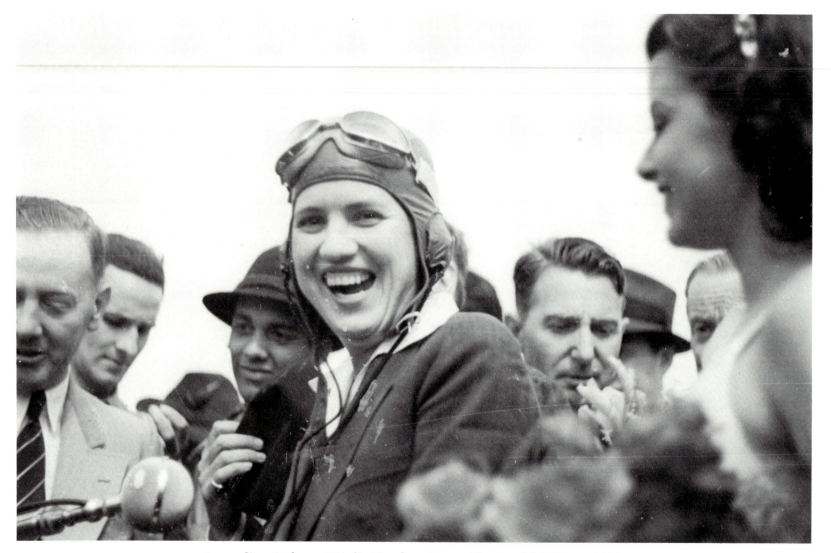

Jacqueline Cochran, Bendix Trophy winner, Cleveland Air Races, 1938.
A superb pilot, Jackie Cochran was voted the world's outstanding woman pilot
for three successive years, 1937–39.

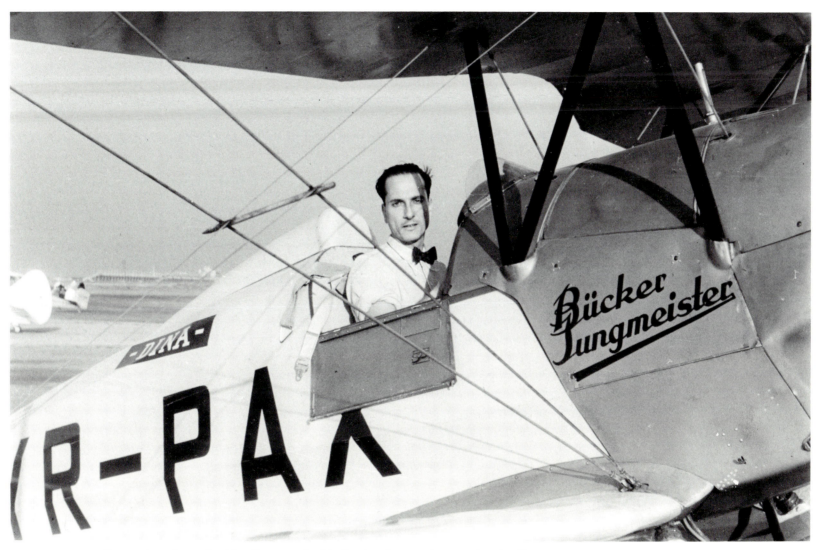

Romanian Captain Alex Papana in his Bücker Jungmeister, Miami All American Air Maneuvers, c. 1939.
Truly one of the great aviation personalities on the air show circuit,
Papana was tennis champion of Romania, holder of several world's motorcycle and automobile
racing records in Europe, and three-time world aerobatic champion.

Gulfhawk II, *Miami All American Air Maneuvers, c. 1939. Al Williams provided thrills for the record crowd at the 1939 Miami air show when he went through his repertoire of precision flying in the stubby little* Gulfhawk II.

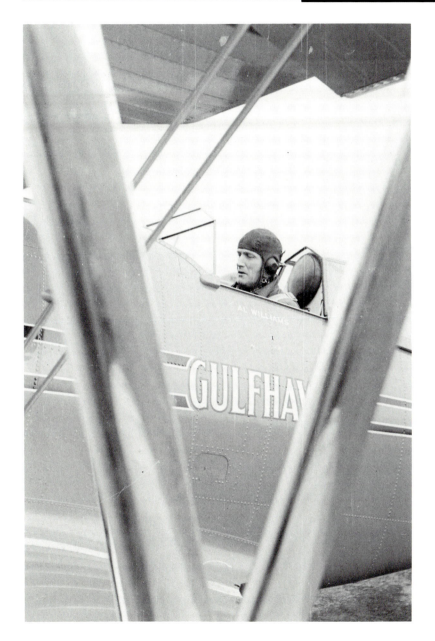

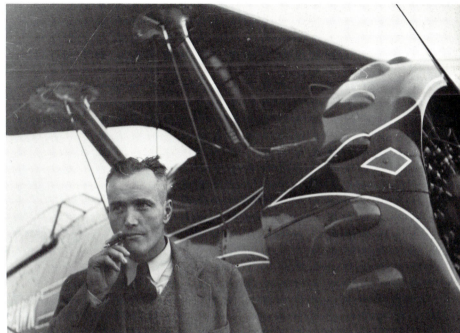

*Major Alford "Al" Williams
and his Grumman G.22.*

Control tower and grandstands, Miami All American Air Maneuvers, 1938. The popular Miami air show was made possible by the cooperation of the aircraft manufacturers and the Gulf Oil Corporation, which supplied gasoline and oil for the hundreds of pilots who flew in from around the nation.

Fairchild PT19, Hagerstown Airport, Pennsylvania, c. 1940. Left wingtip just inches from the ground, plane and pilot stage a spectacular demonstration for the Groenhoff camera.

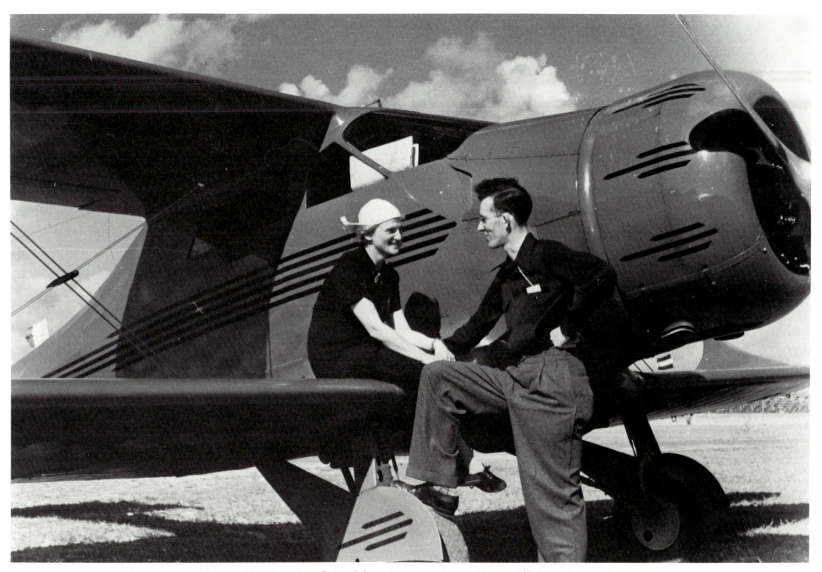

Bessie Owens and Tony LeVier, Beech Model 17 Staggerwing, Miami All American Air Maneuvers, 1939.
Adventurer, author, and world traveler Bessie Owens lent her Staggerwing to racing pilot Tony LeVier
who won second place in the Glen H. Curtiss Trophy race at the Miami show.

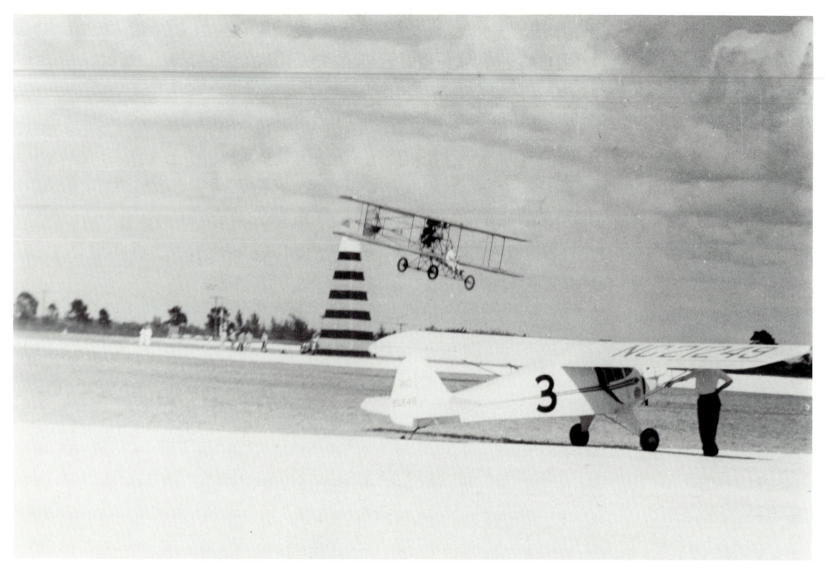

Curtiss E Headless Replica, Miami All American Air Maneuvers, 1939.
The fragile Curtiss E was only one of the many attractions of the 1939 show at Miami,
which featured successful cross-country flights to Miami of almost 500 light planes.

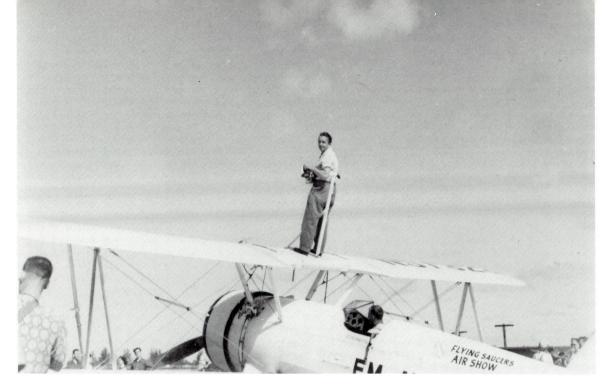

Hans Groenhoff, wing walker. In typical fashion, Groenhoff takes a rather unorthodox approach to obtain a dramatic view of his subject.

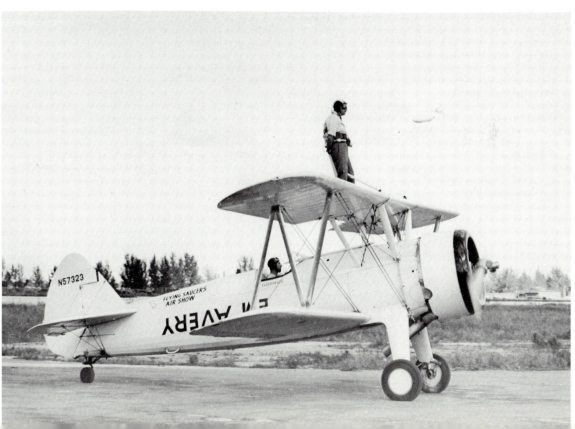

Pylon races, Miami All American Air Maneuvers, 1939. Always a hazardous operation, even with specially designed racing planes and experienced pilots, pylon racing with stock light planes and amateur pilots was a potentially dangerous event.

Fly-by, Miami All American Air Maneuvers, 1936. An aerial parade for the thousands of spectators signals the start of a program of sensational aerobatic demonstrations, races, and fly-bys.

Air Show, Aviation Country Club, 1940. As if on parade to the starting gate, a Rearwin and a Ford invite inspection by members of the prestigious Aviation Country Club of Long Island.

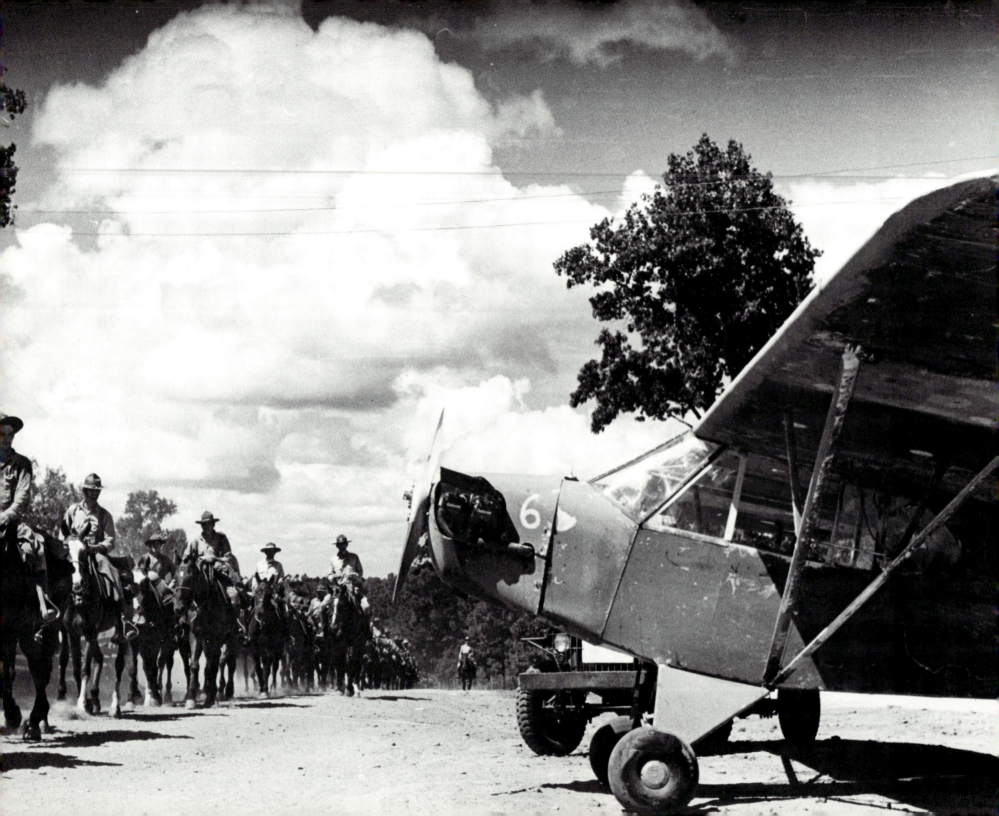

Wings of War

Groenhoff's military photographs of the mid- to late 1930s reflect the growth and development of the Army Air Corps during that critical prewar period. Airshows and displays at military bases such as Wright Field, Ohio; Bolling Field, Washington, D. C.; and Langley Field in Virginia provided him with ideal opportunities to catch the bombers and fighters of the day on parade. As the Douglas B-18s of the late 1930s gradually gave way to the Boeing B-17s in the immediate prewar displays, so did the neat, orderly rows of obsolete Curtiss P-36s at Bolling Field find themselves replaced by sleek, streamlined Bell Airacobras of the 1941 Louisiana maneuvers.

Nearly 850 U. S. Army, Navy, and Marine Corps combat aircraft took part in these large-scale maneuvers staged by the army in Louisiana during September 1941. Wildcats and Helldivers of the navy shared the skies with army Lightnings and Airacobras, and the ubiquitous Groenhoff was there as press photographer

Cavalry and Piper L-4 Grasshoppers,
Louisiana Maneuvers, 1941

and "grasshopper" pilot.

Civilian airplanes and pilots were given quasi-military status by the army for the occasion, and were employed quite successfully as liaison and observation units often attached to forward patrols of the old horse cavalry. Groenhoff and his old friend Bill Piper participated to the fullest, flying their Cubs low and slow over the open fields and country roads of Louisiana to show off the unique capabilities and potential of their "grasshoppers."

Groenhoff thoroughly enjoyed the Louisiana maneuvers, not only from the professional point of view, but for the pure delight of being "able to do anything that was unlawful in flight." Flying out of a Lake Charles schoolyard, Groenhoff and his fellow pilots flew and landed anywhere, spotting cavalry groups by the dust from the country roads and landing on the spot to deliver messages.

In a few months, the idyllic peacetime war games in the deep south were replaced by the grim realities of Pearl Harbor and the entry of the United States into

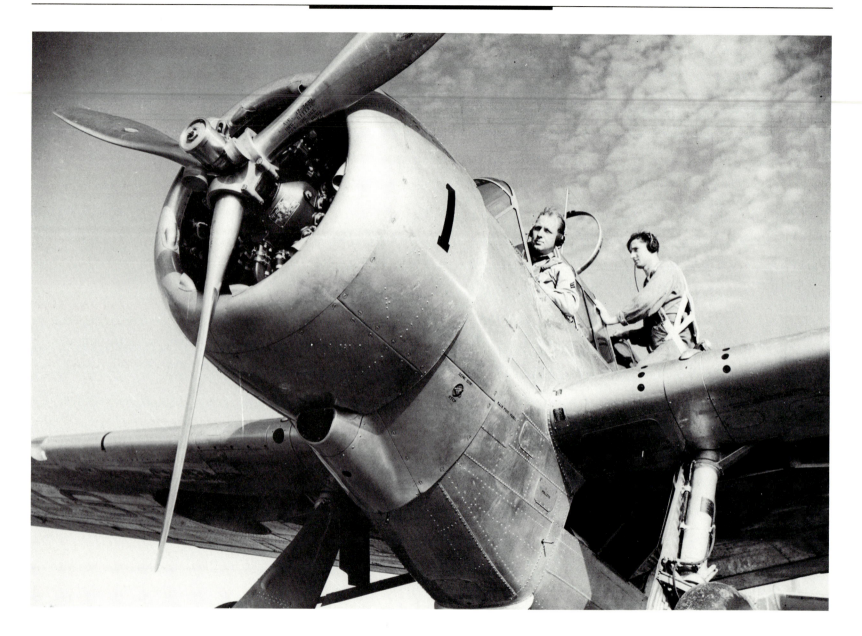

North American O-47, Langley Field. The standard observation aircraft for the army from 1937 until Pearl Harbor, the O-47 was easily distinguished by its deep belly which afforded excellent visibility for an observer photographer. (This page and opposite.)

World War II. In the early days, Groenhoff was asked by the famous photographer Edward Steichen to join his U. S. Navy combat camera team. It was the highest form of tribute to Groenhoff's accomplishments and status as an aviation photographer, a reflection of the great esteem in which he was held by one of the foremost photographers in the United States. Unfortunately, the navy had a stringent restriction on press coverage of official activities. Since Groenhoff was not a second-generation American, he was denied official permission to join Steichen's team. Professionally, it was a deep disappointment to Groenhoff, although he continued to cover U. S. Army aviation throughout the war.

Ironically, the navy restriction conceivably could have saved his life. *Collier's* asked Groenhoff to cover the invasion of Europe in 1944. Again, the navy stepped in, despite clearances from the other services, and prohibited Groenhoff from photographing D-Day. The replacement photographer hired by *Collier's* was killed in the nose of the B-26 bomber in which he was riding on his first mission, in all probability the same mission to which Groenhoff would have been assigned.

Despite the bitter disillusionment he felt at being turned down by the navy, Groenhoff could find solace in the fact that his talents were in great demand elsewhere. As a correspondent for *Life* and *Collier's* with frequent commitments to other periodicals such as *National Geographic* and *Flying*, Groenhoff soon became completely absorbed by his profession. Assignments became less routine, more challenging, and the risks increased proportionately.

Photographing military aircraft provided him with an entirely different set of challenges. Flying in formation aboard the latest model from friend Bill Piper's plant at Lock Haven, Pennsylvania, had often been an enjoyable, if uneventful afternoon's work in the past, despite an occasional mishap now and then. Air speeds were in the sedate 80–90 mph range; the pilots were well briefed. In many instances, they were old friends who had earned Groenhoff's trust and con-

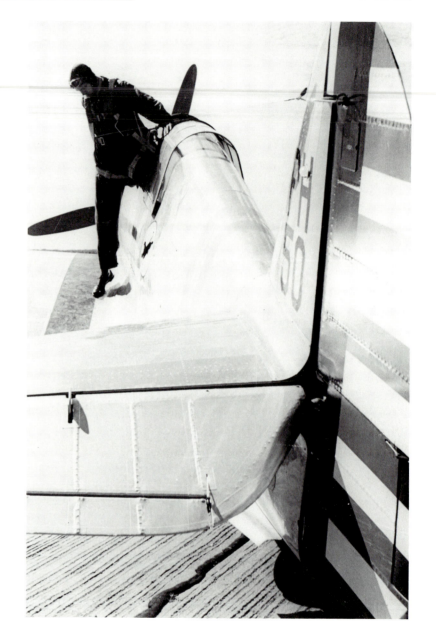

Curtiss P-36A. The leading U.S. Army fighter in the late 1930s, the P-36A saw action at Pearl Harbor and was withdrawn from frontline service shortly thereafter.

fidence on many previous photo missions. Military flying, Groenhoff now quickly discovered, was different—and even more exciting.

There were few challenges that a determined Groenhoff, bent on completing an assignment, could not meet. If the huge wing and tall vertical tail on a Grumman Avenger torpedo bomber obstructed his view of the wing man, then a special platform was constructed on the outside of the airplane to the rear to afford Groenhoff the clear view he required. Of course, military regulations required that he should be tied down while he stood on the platform as the two aircraft flew through their paces at speeds up to 200

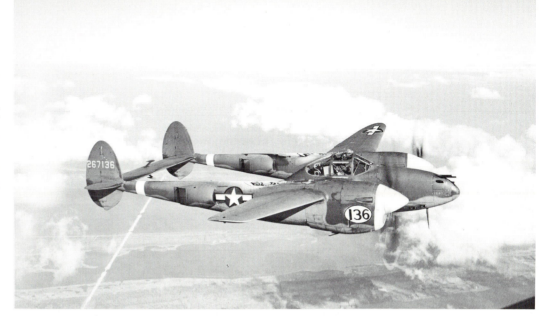

*Lockheed P-38J Lightning.
One of the great fighters of
World War II, the Lightning
remained continuously in
production throughout the
conflict.*

mph. Even Groenhoff admitted that the regulation seemed to be a reasonable request at the time.

Taking some photographs for *Life* on a practice bombing mission presented an altogether different challenge on one occasion. After a rather dull session during which Groenhoff photographed bombs falling away from another Flying Fortress in the formation, Groenhoff decided that a view from the bomb bay would provide the unique perspective he needed. As he climbed down into the bomb bay, loaded down with the necessary equipment, the doors opened in preparation for the drop. Groenhoff was struck violently by the 150 mph blast of wind as it roared through the open bay. He lost his balance, and only with a frantic, final grab at something as he floated by on the way out with the bombs, was he able to save himself—and his camera—"so I could finally get the pictures!"

Of all of the harrowing stories that emerged from World War II concerning the now legendary Groenhoff, the "glider story" most accurately reflects the fierce determination and singlemindedness that characterized his approach to the job.

On the occasion of some wartime maneuvers of army paratroopers and glider troops in 1944, Groenhoff was assigned to cover the airborne maneuvers of the gliders and tow planes as they delivered combat troops to their drop zones in the North Carolina countryside. A flimsy, fabric-covered CG-4A troop glider, capable of carrying 15 fully equipped troops, was designated as Groenhoff's transport. In accordance with standard Groenhoff operating procedures, the glider had been stripped of its door, escape hatch cover, and all side windows so as to provide him with a clear view of the C-47 towplane and another CG-4A, companion of Groenhoff's glider during the double-tow takeoff. In special recognition of Groenhoff's previous experience as a glider pilot, he was to be afforded the privilege of piloting and landing the CG-4A at the conclusion of the flight. In addition to the pilot, fellow correspondent Martin Caidin accompanied Groenhoff on the mission.

Several minutes before the designated takeoff time, Groenhoff was engaged in taking photographs of the C-47 as it sat on the runway, engines idling, the long nylon

towlines connecting the towplane and the two gliders neatly arranged on the runway. Suddenly, without warning, the engines of the C-47 roared to life. The airplane began to move, slowly at first, gradually picking up speed. As the towlines began to tighten, Groenhoff, loaded down with assorted cameras and paraphernalia, galloped for the glider, urged on by the frantic shouts of Caidin, now safely on board. As the C-47 lifted off, the CG-4A began to accelerate down the runway. With a last desperate leap, Groenhoff made it, just as the glider became airborne.

Actually, only half of Groenhoff made it through the glider's hatch. The opening was too narrow for his equipment; camera cases, film canisters, and assorted light meters, all attached to Groenhoff, would not fit through the hatch. As the glider reached 1,000 feet, still climbing, Groenhoff hung on for his life, body and equipment flailing away in the 150 mph wind blast. Caidin frantically tried to pull Groenhoff into the cabin; the pilot, oblivious to the drama taking place a few feet behind him, flew on, intent on maintaining his proper position in relation to the C-47 and the other CG-4A.

As the two men struggled desperately, an incident occurred that, perhaps more than any other single event, dramatically illustrated Groenhoff's obsessive tenacity and sense of purpose. A film canister broke open, several rolls of precious color film fell out and began to roll haphazardly around the open cabin. Fearing the loss of the rare film, Groenhoff totally forgot his predicament, fought off the assistance of Caidin, and screamed at him to rescue the film. At precisely that moment, the pilot threw the glider into a steep vertical bank. Caidin grabbed for the nearest support; Groenhoff somersaulted into the cabin, landed on his back, and as the pilot rolled out of his turn, proceeded to slide toward the open hatch on the opposite side of the aircraft! Still screaming about his now-disappearing color film, Groenhoff skidded partially out the other hatch, feet first— to be brought to an abrupt halt by the very equipment that had precipitated the crisis in the first place. The subsequent rescue by Caidin seemed like an afterthought.

Utterly shattered by the loss of the film, Groenhoff stalked up to the cockpit, took over the controls from the pilot, and brought the glider back for a perfect landing. The Groenhoff legend continued to grow.

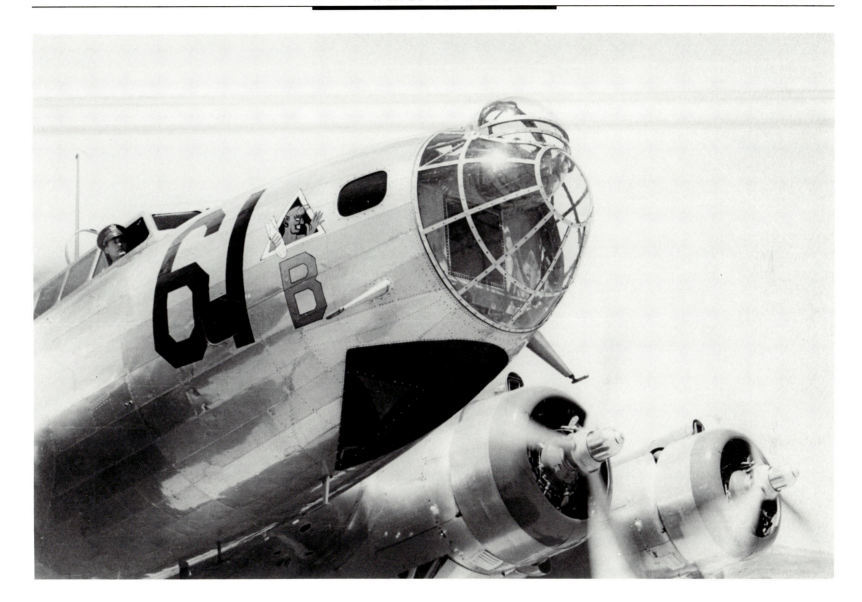

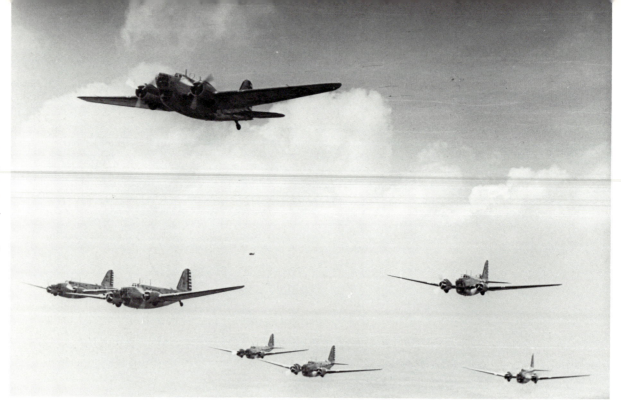

Douglas B-18As, Wright Field, Dayton, Ohio, 1935. Bearing a resemblance to their distant cousin, the Douglas DC-2, B-18/B-18A bombers were obsolete by 1941, and were used primarily for anti-submarine warfare operations during World War II.

Curtiss P-40B, c. 1941. Over 13,700 P-40s of various types were built during World War II and used quite effectively by the British in North Africa and by the famous Flying Tigers in China.

Airshow, Bolling Field, Washington, D. C., 1939. Northrop A-17As, Martin B-10s, Curtiss P-36As, and Douglas B-18As are among the classic aircraft featured in this prewar display.

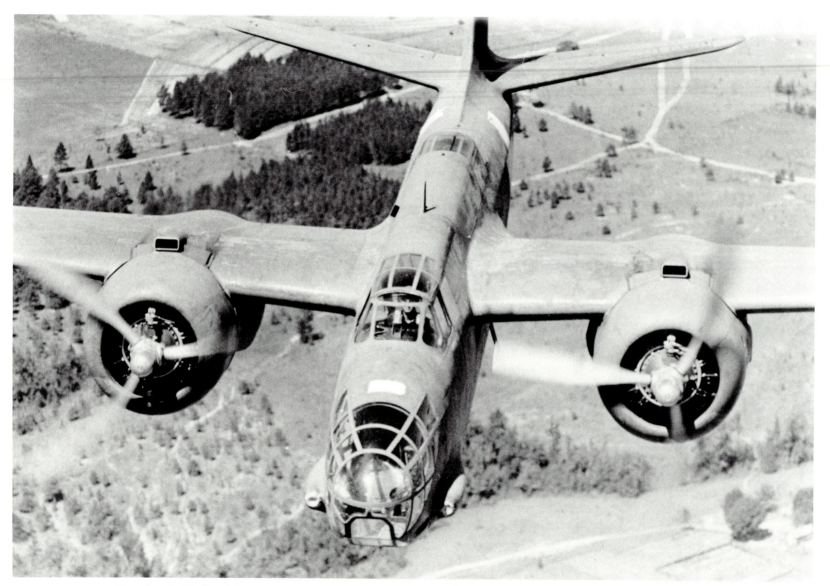

Douglas A-20, Louisiana maneuvers, 1941. U.S. Army pilots demonstrated the outstanding qualities of the A-20 Havoc during the war exercises in Louisiana in September 1941.

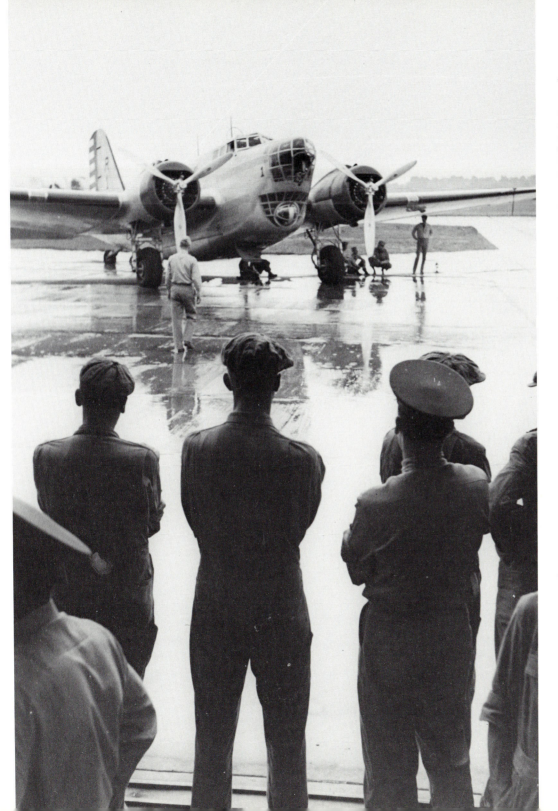

Douglas B-18A, Mitchel Field, New York, c. 1937. With the bombardier's station extended forward over the nose turret for better visibility and comfort, the docile B-18A assumed a rather menacing, sharklike appearance.

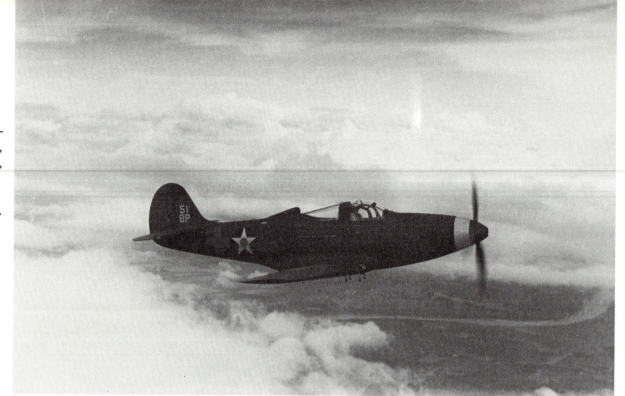

Bell P-39 Airacobra, Louisiana maneuvers, 1941. The Airacobra's engine was, uniquely, behind the pilot's cockpit, permitting installation of a cannon in the nose of the airplane.

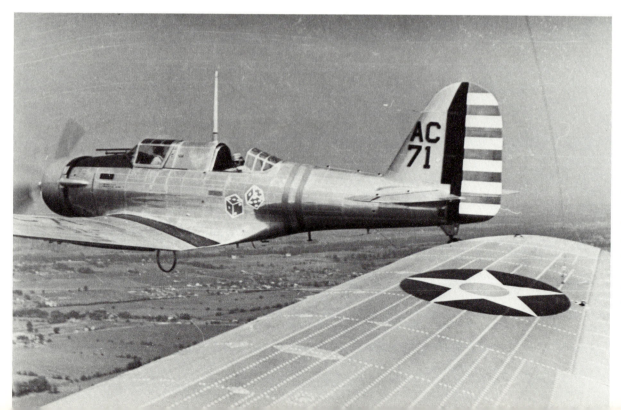

Northrop A-17A, c. 1937. A development of the famous Northrop Gamma and Delta all-metal monoplanes, the Northrop A-17A served briefly with the U.S. Army, after which many were sold to Great Britain and France at the onset of World War II.

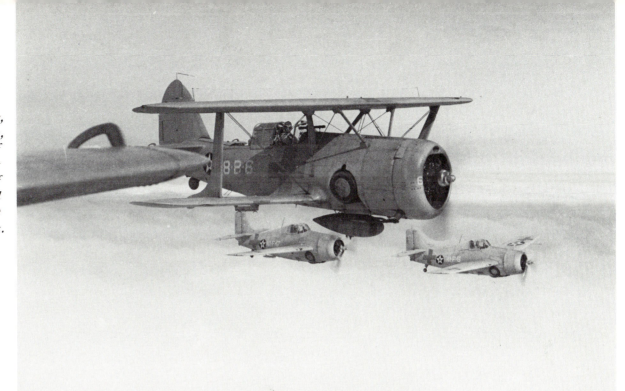

Curtiss SBC-4 Helldiver, Grumman F4F-3 Wildcats, 1941. An interesting mix of old and new: an obsolescent SBC-4 of the "Red" forces of the 1941 war games is escorted by two of the newest, fastest monoplane U.S. Navy fighters.

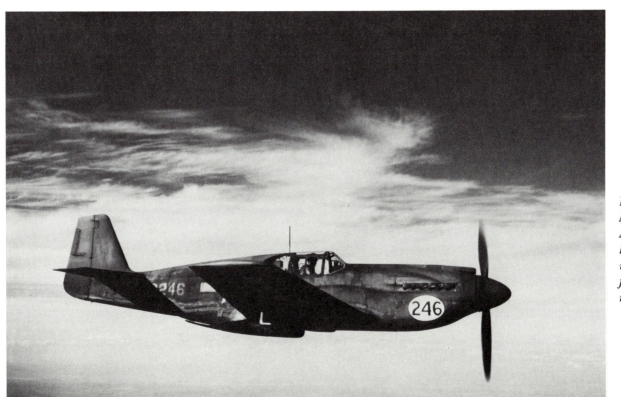

North American P-51A Mustang. Mustangs could escort Allied bombers all the way to Berlin from bases in England, whereas Spitfires and other fighter aircraft lacked the necessary range.

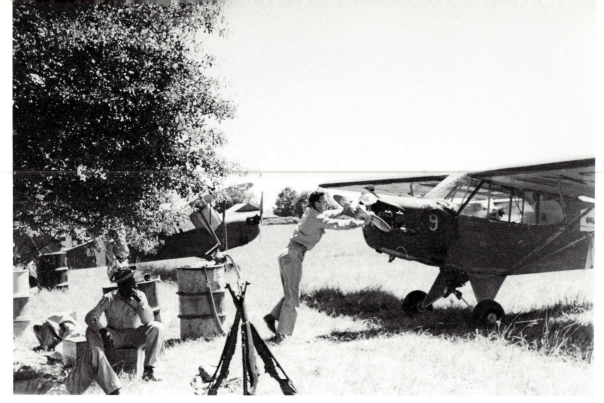

Piper L-4 Grasshoppers, Louisiana Maneuvers, 1941. Civilian airplanes and pilots excelled in performing observation and liaison duties during the maneuvers.

Consolidated PB-2As, night operations, Mitchel Field, near Farmingdale, New York, c. 1938. A row of turbo-supercharged PB-2As is caught in the beam of a searchlight during night maneuvers by the Air Corps.

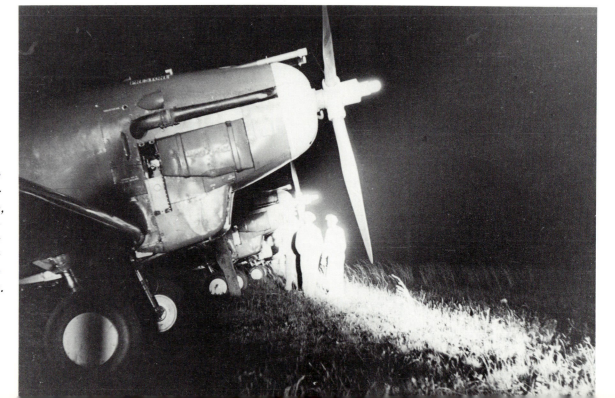

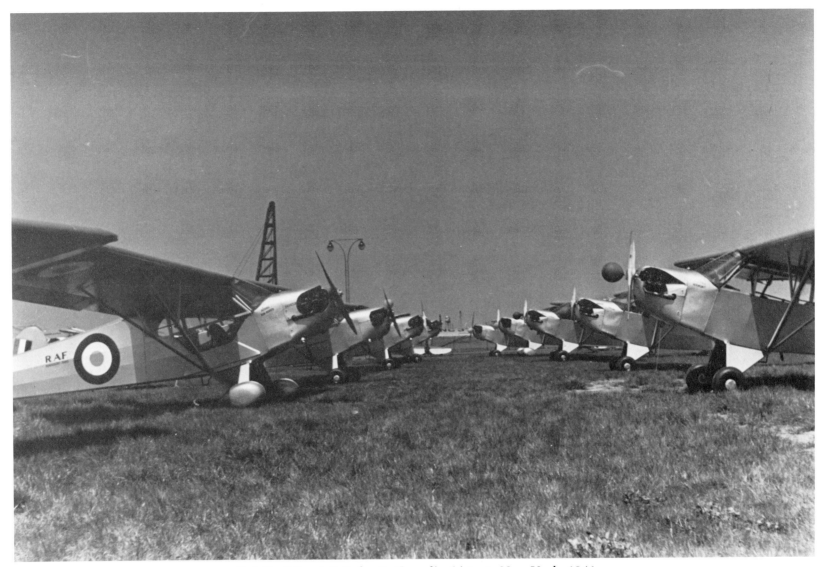

R.A.F. Piper J-3 Cubs, LaGuardia Airport, New York, 1941.
Forty-eight Piper Cubs, each one named for a state of the United States, participated in a
demonstration on behalf of the Royal Air Force Benevolent Fund campaign.

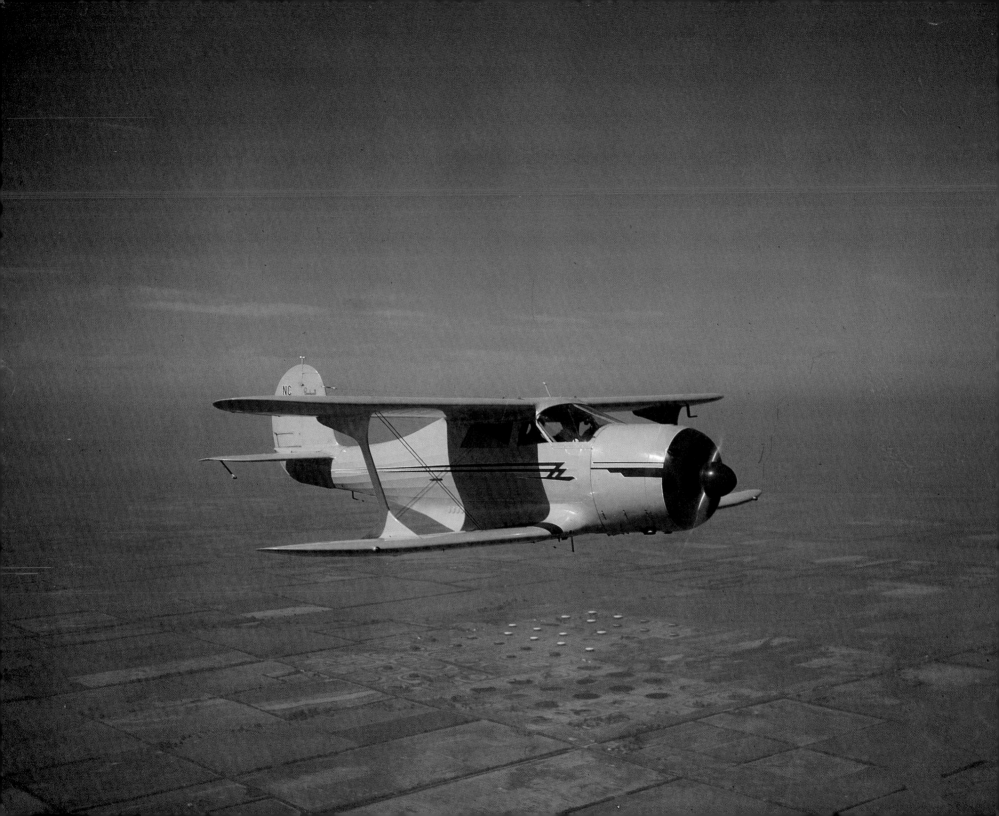

A Color Album

For forty years, Groenhoff's color photographs set the standard of excellence against which others in the profession were measured.

I started using color film when Kodacolor first came out. It was a very slow film at that time and it was very difficult to take fast action photographs with it. In all my aerial shots, I had to insist that both planes flew in perfect formation so that there was no speed difference so that I could shoot at longer exposure times.

I lived next to LaGuardia Field, and I had a basement which was converted into a lab. I did all my own processing; sometimes coming back from an assignment, I would stay up all night and process the films I did. Color, I did not process. It was impossible at that time, but through my connection working for Life *and* Collier's *and so forth, they often made me stop at Rochester on the way home, and Kodak would do a special job in developing these films which helped a great deal. As I said, the 4x5 inch color film was very slow. It had to be loaded into individual holders and in addition to*

Beechcraft Model 17

having all that equipment in the airplane next to me, I was surrounded by cameras and holders. It was a difficult job. Groenhoff caught the elegance and grace of the fragile, birdlike sailplanes at Elmira in the late 1930s. As military preparedness increased and the United States moved closer to a wartime posture, Groenhoff's color photographs of the latest fighters and bombers were in great demand. His color work of military aviation during World War II was superb, often unmatched, both technically and aesthetically. So much in favor was Groenhoff with the air force and the various manufacturers, that unofficial color schemes would often be adapted to a military aircraft to satisfy Groenhoff's sense of style and beauty.

"I like contrast," he said. "I like saturated colors because the photo is more spectacular. The sky is deep blue, and the airplanes are very colorful—the yellows, the yellow airplanes against a blue sky. When I photographed for *Life*, they had a catalog of U. S. Air Force World War II aircraft. I had airplanes specially painted. Sometimes when

Martin B-26B, c. 1942

you have a big magazine to work for, you can have anything done. For instance, they would paint a shark's head on some of the airplanes, or paint special stripes. Camouflage colors were so dull and uninteresting, so I asked what is the color of your group or your squadron, or I could even put a big yellow stripe down the fuselage, and the magazine did all that. It was amazing."

Groenhoff's move south to Florida and subsequently to the Bahamas was a fortuitous one for several reasons. The

clouds, the sky, the entire ambience were a welcome change, providing opportunities for fresh innovative approaches to his work. The majesty of the Manhattan skyline, the rolling hills of Elmira, the dingy Hudson River had served Groenhoff well, and their contributions to his earlier photography were significant and unique. Eventually, however, white sand, turquoise sea, and green palm trees became predominant. A specially painted Piper or Cessna frequently provided a colorful contrast. But even those disappeared as Groenhoff concentrated more and more on his duties with the Ministry of Tourism for the Bahamas.

Groenhoff's move to the Bahamas marked the end of his career as an aviation photographer. But the life there also brought with it a new sense of freedom, of release from many of the restrictions, regulations, and conventions that seemed to have plagued Groenhoff throughout his life. He could enjoy flying perhaps more than ever before.

"Flying used to be a great attraction. But it isn't anymore. It's just a means of transportation. It has become too sophisticated; the requirements are too stringent. You have to observe too many rules and regulations which we didn't have."

"Oh, that was wonderful flying in the Bahamas. In the Bahamas, there were absolutely no restrictions. You would fly anytime, anywhere. The weather usually was nice. We didn't have to hear a weather report. We just took off and flew—to other islands, wherever we wanted to go."

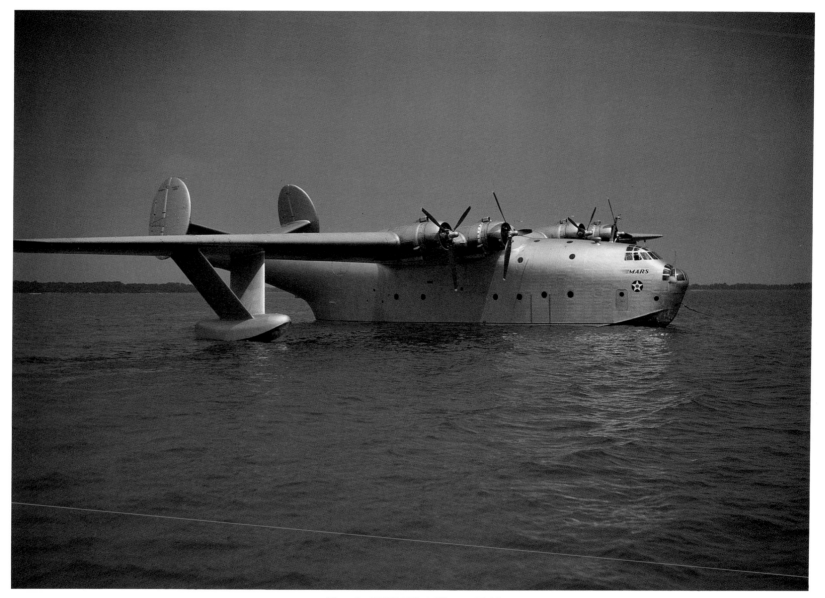

Martin XPB2M-1 Mars, 1942

Boeing XB-15, c. 1939

Aeronca Champion

Ross RS-1 Zanonia,
Elmira, 1948

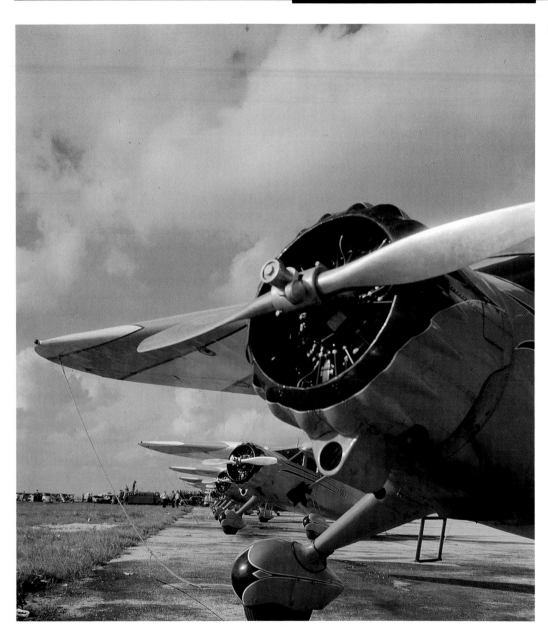

Stinson Reliant, c. 1937

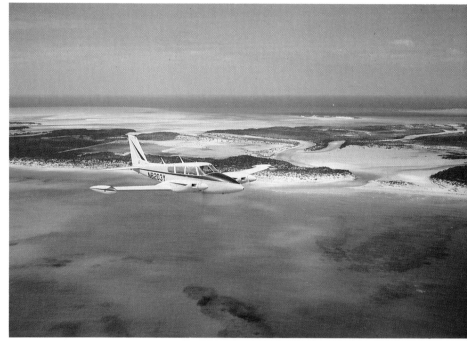

Piper Commanche, Bahama Islands

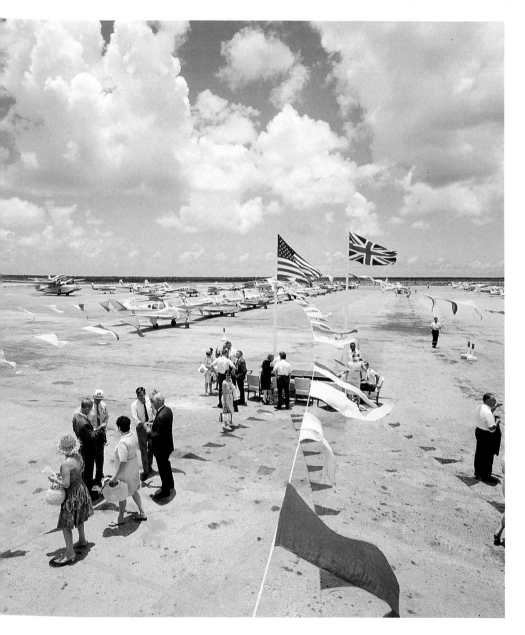

**Bahamas Flying Treasure
Hunt finish line, Bahamas
International Airport, 1968**

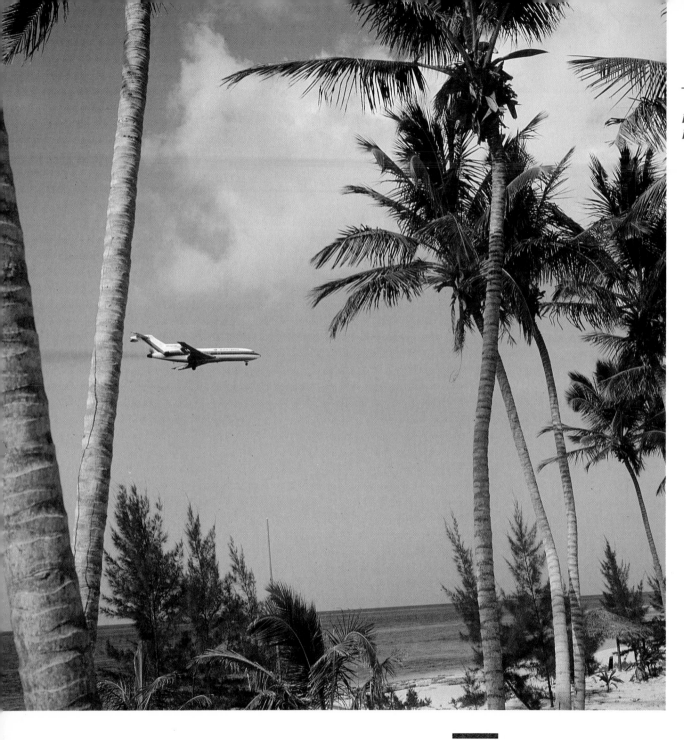

*Boeing 727, Bahamas
International Airport*

108